PENGUIN BOOKS

ON PHOTOGRAPHY

Susan Sontag was born in Manhattan in 1933. She was a philosopher, writer, filmmaker and political activist, and is widely considered to be one of the most influential thinkers of her generation. Her non-fiction works include *Against Interpretation*, *On Photography*, *Illness as Metaphor*, *Regarding the Pain of Others* and *Notes on Camp*, and two volumes of diaries, *Reborn* and *As Consciousness is Harnessed to Flesh*. She is also the author of several novels, stories and plays. Her books have won multiple prizes and have been translated into thirty-two languages. Susan Sontag died in December 2004.

On Photography

SUSAN SONTAG

PENGUIN BOOKS

PENGUIN BOOKS

UK | USA | Canada | Ireland | Australia
India | New Zealand | South Africa

Penguin Books is part of the Penguin Random House group of companies
whose addresses can be found at global.penguinrandomhouse.com.

First published in Canada and the United States of America by Farrar, Straus and Giroux 1977
First published in Great Britain by Allen Lane 1978
Published in Penguin Books 1979
This edition published 2019

045

Set in 11.5/16pt Dante MT Std
Typeset by Jouve (UK), Milton Keynes
Printed and bound in Great Britain by Clays Ltd, Elcograf S.p.A.

A CIP catalogue record for this book is available from the British Library

ISBN: 978-0-140-05397-5

www.greenpenguin.co.uk

for Nicole Stéphane

It all started with one essay – about some of the problems, aesthetic and moral, posed by the omnipresence of photographed images: but the more I thought about what photographs are, the more complex and suggestive they became. So one generated another, and that one (to my bemusement) another, and so on – a progress of essays, about the meaning and career of photographs – until I'd gone far enough so that the argument sketched in the first essay, documented and digressed from in the succeeding essays, could be recapitulated and extended in a more theoretical way; and could stop.

The essays were first published (in a slightly different form) in *The New York Review of Books*, and probably would never have been written were it not for the encouragement given by its editors, my friends Robert Silvers and Barbara Epstein, to my obsession with photography. I am grateful to them, and to my friend Don Eric Levine, for much patient advice and unstinting help.

S.S.

May 1977

Contents

In Plato's Cave

Humankind lingers unregenerately in Plato's cave, still reveling, its age-old habit, in mere images of the truth. But being educated by photographs is not like being educated by older, more artisanal images. For one thing, there are a great many more images around, claiming our attention. The inventory started in 1839 and since then just about everything has been photographed, or so it seems. This very insatiability of the photographing eye changes the terms of confinement in the cave, our world. In teaching us a new visual code, photographs alter and enlarge our notions of what is worth looking at and what we have a right to observe. They are a grammar and, even more importantly, an ethics of seeing. Finally, the most grandiose result of the photographic enterprise is to give us the sense that we can hold the whole world in our heads—as an anthology of images.

To collect photographs is to collect the world. Movies and television programs light up walls, flicker, and go out; but with still photographs the image is also an object, light-weight, cheap to produce, easy to carry about, accumulate, store. In Godard's *Les Carabiners* (1963), two sluggish lumpen-peasants are lured

into joining the King's Army by the promise that they will be able to loot, rape, kill, or do whatever else they please to the enemy, and get rich. But the suitcase of booty that Michel-Ange and Ulysse triumphantly bring home, years later, to their wives turns out to contain only picture postcards, hundreds of them, of Monuments, Department Stores, Mammals, Wonders of Nature, Methods of Transport, Works of Art, and other classified treasures from around the globe. Godard's gag vividly parodies the equivocal magic of the photographic image. Photographs are perhaps the most mysterious of all the objects that make up, and thicken, the environment we recognize as modern. Photographs really are experience captured, and the camera is the ideal arm of consciousness in its acquisitive mood.

To photograph is to appropriate the thing photographed. It means putting oneself into a certain relation to the world that feels like knowledge—and, therefore, like power. A now notorious first fall into alienation, habituating people to abstract the world into printed words, is supposed to have engendered that surplus of Faustian energy and psychic damage needed to build modern, inorganic societies. But print seems a less treacherous form of leaching out the world, of turning it into a mental object, than photographic images, which now provide most of the knowledge people have about the look of the past and the reach of the present. What is written about a person or an event is frankly an interpretation, as are handmade visual statements, like paintings and drawings. Photographed images do

not seem to be statements about the world so much as pieces of it, miniatures of reality that anyone can make or acquire.

Photographs, which fiddle with the scale of the world, themselves get reduced, blown up, cropped, retouched, doctored, tricked out. They age, plagued by the usual ills of paper objects; they disappear; they become valuable, and get bought and sold; they are reproduced. Photographs, which package the world, seem to invite packaging. They are stuck in albums, framed and set on tables, tacked on walls, projected as slides. Newspaper and magazines feature them; cops alphabetize them; museums exhibit them; publishers compile them.

For many decades the book has been the most influential way of arranging (and usually miniaturizing) photographs, thereby guaranteeing them longevity, if not immortality—photographs are fragile objects, easily torn or mislaid—and a wider public. The photograph in a book is, obviously, the image of an image. But since it is, to begin with, a printed, smooth object, a photograph loses much less of its essential quality when reproduced in a book than a painting does. Still, the book is not a wholly satisfactory scheme for putting groups of photographs into general circulation. The sequence in which the photographs are to be looked at is proposed by the order of pages, but nothing holds readers to the recommended order or indicates the amount of time to be spent on each photograph. Chris Marker's film, *Si j'avais quatre dromadaires* (1966), a brilliantly orchestrated meditation on

photographs of all sorts and themes, suggests a subtler and more rigorous way of packaging (and enlarging) still photographs. Both the order and the exact time for looking at each photograph are imposed; and there is a gain in visual legibility and emotional impact. But photographs transcribed in a film cease to be collectable objects, as they still are when served up in books.

PHOTOGRAPHS FURNISH EVIDENCE. SOMETHING we hear about, but doubt, seems proven when we're shown a photograph of it. In one version of its utility, the camera record incriminates. Starting with their use by the Paris police in the murderous roundup of Communards in June 1871, photographs became a useful tool of modern states in the surveillance and control of their increasingly mobile populations. In another version of its utility, the camera record justifies. A photograph passes for incontrovertible proof that a given thing happened. The picture may distort; but there is always a presumption that something exists, or did exist, which is like what's in the picture. Whatever the limitations (through amateurism) or pretensions (through artistry) of the individual photographer, a photograph—any photograph—seems to have a more innocent, and therefore more accurate, relation to visible reality than do other mimetic objects. Virtuosi of the noble image like Alfred Stieglitz and Paul Strand, composing mighty, unforgettable photographs decade after decade, still want, first of all, to show something "out there," just like the Polaroid

owner for whom photographs are a handy, fast form of note-taking, or the shutterbug with a Brownie who takes snapshots as souvenirs of daily life.

While a painting or a prose description can never be other than a narrowly selective interpretation, a photograph can be treated as a narrowly selective transparency. But despite the presumption of veracity that gives all photographs authority, interest, seductiveness, the work that photographers do is no generic exception to the usually shady commerce between art and truth. Even when photographers are most concerned with mirroring reality, they are still haunted by tacit imperatives of taste and conscience. The immensely gifted members of the Farm Security Administration photographic project of the late 1930s (among them Walker Evans, Dorothea Lange, Ben Shahn, Russell Lee) would take dozens of frontal pictures of one of their sharecropper subjects until satisfied that they had gotten just the right look on film—the precise expression on the subject's face that supported their own notions about poverty, light, dignity, texture, exploitation, and geometry. In deciding how a picture should look, in preferring one exposure to another, photographers are always imposing standards on their subjects. Although there is a sense in which the camera does indeed capture reality, not just interpret it, photographs are as much an interpretation of the world as paintings and drawings are. Those occasions when the taking of photographs is relatively undiscriminating, promiscuous, or self-effacing do not lessen the didacticism of the whole

enterprise. This very passivity—and ubiquity—of the photographic record is photography's "message," its aggression.

Images which idealize (like most fashion and animal photography) are no less aggressive than work which makes a virtue of plainness (like class pictures, still lifes of the bleaker sort, and mug shots). There is an aggression implicit in every use of the camera. This is as evident in the 1840s and 1850s, photography's glorious first two decades, as in all the succeeding decades, during which technology made possible an ever increasing spread of that mentality which looks at the world as a set of potential photographs. Even for such early masters as David Octavius Hill and Julia Margaret Cameron who used the camera as a means of getting painterly images, the point of taking photographs was a vast departure from the aims of painters. From its start, photography implied the capture of the largest possible number of subjects. Painting never had so imperial a scope. The subsequent industrialization of camera technology only carried out a promise inherent in photography from its very beginning: to democratize all experiences by translating them into images.

That age when taking photographs required a cumbersome and expensive contraption—the toy of the clever, the wealthy, and the obsessed—seems remote indeed from the era of sleek pocket cameras that invite anyone to take pictures. The first cameras, made in France and England in the early 1840s, had only inventors and buffs to operate them. Since there were then no professional photographers, there could not be amateurs

either, and taking photographs had no clear social use; it was a gratuitous, that is, an artistic activity, though with few pretensions to being an art. It was only with its industrialization that photography came into its own as art. As industrialization provided social uses for the operations of the photographer, so the reaction against these uses reinforced the self-consciousness of photography-as-art.

RECENTLY, PHOTOGRAPHY HAS BECOME almost as widely practiced an amusement as sex and dancing—which means that, like every mass art form, photography is not practiced by most people as an art. It is mainly a social rite, a defense against anxiety, and a tool of power.

Memorializing the achievements of individuals considered as members of families (as well as of other groups) is the earliest popular use of photography. For at least a century, the wedding photograph has been as much a part of the ceremony as the prescribed verbal formulas. Cameras go with family life. According to a sociological study done in France, most households have a camera, but a household with children is twice as likely to have at least one camera as a household in which there are no children. Not to take pictures of one's children, particularly when they are small, is a sign of parental indifference, just as not turning up for one's graduation picture is a gesture of adolescent rebellion.

Through photographs, each family constructs a portrait-chronicle of itself—a portable kit of images that bears witness

to its connectedness. It hardly matters what activities are photographed so long as photographs get taken and are cherished. Photography becomes a rite of family life just when, in the industrializing countries of Europe and America, the very institution of the family starts undergoing radical surgery. As that claustrophobic unit, the nuclear family, was being carved out of a much larger family aggregate, photography came along to memorialize, to restate symbolically, the imperiled continuity and vanishing extendedness of family life. Those ghostly traces, photographs, supply the token presence of the dispersed relatives. A family's photograph album is generally about the extended family—and, often, is all that remains of it.

As photographs give people an imaginary possession of a past that is unreal, they also help people to take possession of space in which they are insecure. Thus, photography develops in tandem with one of the most characteristic of modern activities: tourism. For the first time in history, large numbers of people regularly travel out of their habitual environments for short periods of time. It seems positively unnatural to travel for pleasure without taking a camera along. Photographs will offer indisputable evidence that the trip was made, that the program was carried out, that fun was had. Photographs document sequences of consumption carried on outside the view of family, friends, neighbors. But dependence on the camera, as the device that makes real what one is experiencing, doesn't fade when people travel more. Taking

photographs fills the same need for the cosmopolitans accumulating photograph-trophies of their boat trip up the Albert Nile or their fourteen days in China as it does for lower-middle-class vacationers taking snapshots of the Eiffel Tower or Niagara Falls.

A way of certifying experience, taking photographs is also a way of refusing it—by limiting experience to a search for the photogenic, by converting experience into an image, a souvenir. Travel becomes a strategy for accumulating photographs. The very activity of taking pictures is soothing, and assuages general feelings of disorientation that are likely to be exacerbated by travel. Most tourists feel compelled to put the camera between themselves and whatever is remarkable that they encounter. Unsure of other responses, they take a picture. This gives shape to experience: stop, take a photograph, and move on. The method especially appeals to people handicapped by a ruthless work ethic—Germans, Japanese, and Americans. Using a camera appeases the anxiety which the work-driven feel about not working when they are on vacation and supposed to be having fun. They have something to do that is like a friendly imitation of work: they can take pictures.

People robbed of their past seem to make the most fervent picture takers, at home and abroad. Everyone who lives in an industrialized society is obliged gradually to give up the past, but in certain countries, such as the United States and Japan, the break with the past has been particularly traumatic. In the

early 1970s, the fable of the brash American tourist of the 1950s and 1960s, rich with dollars and Babbittry, was replaced by the mystery of the group-minded Japanese tourist, newly released from his island prison by the miracle of overvalued yen, who is generally armed with two cameras, one on each hip.

Photography has become one of the principal devices for experiencing something, for giving an appearance of participation. One full-page ad shows a small group of people standing pressed together, peering out of the photograph, all but one looking stunned, excited, upset. The one who wears a different expression holds a camera to his eye; he seems self-possessed, is almost smiling. While the others are passive, clearly alarmed spectators, having a camera has transformed one person into something active, a voyeur: only he has mastered the situation. What do these people see? We don't know. And it doesn't matter. It is an Event: something worth seeing—and therefore worth photographing. The ad copy, white letters across the dark lower third of the photograph like news coming over a teletype machine, consists of just six words: ". . . Prague . . . Woodstock . . . Vietnam . . . Sapporo . . . Londonderry . . . LEICA." Crushed hopes, youth antics, colonial wars, and winter sports are alike—are equalized by the camera. Taking photographs has set up a chronic voyeuristic relation to the world which levels the meaning of all events.

A photograph is not just the result of an encounter between an event and a photographer; picture-taking is an event in itself,

and one with ever more peremptory rights—to interfere with, to invade, or to ignore whatever is going on. Our very sense of situation is now articulated by the camera's interventions. The omnipresence of cameras persuasively suggests that time consists of interesting events, events worth photographing. This, in turn, makes it easy to feel that any event, once underway, and whatever its moral character, should be allowed to complete itself—so that something else can be brought into the world, the photograph. After the event has ended, the picture will still exist, conferring on the event a kind of immortality (and importance) it would never otherwise have enjoyed. While real people are out there killing themselves or other real people, the photographer stays behind his or her camera, creating a tiny element of another world: the image-world that bids to outlast us all.

Photographing is essentially an act of non-intervention. Part of the horror of such memorable coups of contemporary photojournalism as the pictures of a Vietnamese bonze reaching for the gasoline can, of a Bengali guerrilla in the act of bayoneting a trussed-up collaborator, comes from the awareness of how plausible it has become, in situations where the photographer has the choice between a photograph and a life, to choose the photograph. The person who intervenes cannot record; the person who is recording cannot intervene. Dziga Vertov's great film, *Man with a Movie Camera* (1929), gives the ideal image of the photographer as someone in perpetual movement, someone moving through a panorama of disparate

events with such agility and speed that any intervention is out of the question. Hitchcock's *Rear Window* (1954) gives the complementary image: the photographer played by James Stewart has an intensified relation to one event, through his camera, precisely because he has a broken leg and is confined to a wheelchair; being temporarily immobilized prevents him from acting on what he sees, and makes it even more important to take pictures. Even if incompatible with intervention in a physical sense, using a camera is still a form of participation. Although the camera is an observation station, the act of photographing is more than passive observing. Like sexual voyeurism, it is a way of at least tacitly, often explicitly, encouraging whatever is going on to keep on happening. To take a picture is to have an interest in things as they are, in the status quo remaining unchanged (at least for as long as it takes to get a "good" picture), to be in complicity with whatever makes a subject interesting, worth photographing—including, when that is the interest, another person's pain or misfortune.

"I ALWAYS THOUGHT OF photography as a naughty thing to do—that was one of my favorite things about it," Diane Arbus wrote, "and when I first did it I felt very perverse." Being a professional photographer can be thought of as naughty, to use Arbus's pop word, if the photographer seeks out subjects considered to be disreputable, taboo, marginal. But naughty subjects are harder to find these days. And what exactly is the perverse aspect of picture-taking? If

professional photographers often have sexual fantasies when they are behind the camera, perhaps the perversion lies in the fact that these fantasies are both plausible and so inappropriate. In *Blowup* (1966), Antonioni has the fashion photographer hovering convulsively over Verushka's body with his camera clicking. Naughtiness, indeed! In fact, using a camera is not a very good way of getting at someone sexually. Between photographer and subject, there has to be distance. The camera doesn't rape, or even possess, though it may presume, intrude, trespass, distort, exploit, and, at the farthest reach of metaphor, assassinate—all activities that, unlike the sexual push and shove, can be conducted from a distance, and with some detachment.

There is a much stronger sexual fantasy in Michael Powell's extraordinary movie *Peeping Tom* (1960), which is not about a Peeping Tom but about a psychopath who kills women with a weapon concealed in his camera, while photographing them. Not once does he touch his subjects. He doesn't desire their bodies; he wants their presence in the form of filmed images—those showing them experiencing their own death—which he screens at home for his solitary pleasure. The movie assumes connections between impotence and aggression, professionalized looking and cruelty, which point to the central fantasy connected with the camera. The camera as phallus is, at most, a flimsy variant of the inescapable metaphor that everyone unselfconsciously employs. However hazy our awareness of this fantasy, it is named without subtlety

whenever we talk about "loading" and "aiming" a camera, about "shooting" a film.

The old-fashioned camera was clumsier and harder to reload than a brown Bess musket. The modern camera is trying to be a ray gun. One ad reads:

The Yashica Electro-35 GT is the spaceage camera your family will love. Take beautiful pictures day or night. Automatically. Without any nonsense. Just aim, focus and shoot. The GT's computer brain and electronic shutter will do the rest.

Like a car, a camera is sold as a predatory weapon—one that's as automated as possible, ready to spring. Popular taste expects an easy, an invisible technology. Manufacturers reassure their customers that taking pictures demands no skill or expert knowledge, that the machine is all-knowing, and responds to the slightest pressure of the will. It's as simple as turning the ignition key or pulling the trigger.

Like guns and cars, cameras are fantasy-machines whose use is addictive. However, despite the extravagances of ordinary language and advertising, they are not lethal. In the hyperbole that markets cars like guns, there is at least this much truth: except in wartime, cars kill more people than guns do. The camera/gun does not kill, so the ominous metaphor seems to be all bluff—like a man's fantasy of having a gun, knife, or tool between his legs. Still, there is something predatory in the act of taking a picture. To photograph people

is to violate them, by seeing them as they never see themselves, by having knowledge of them they can never have; it turns people into objects that can be symbolically possessed. Just as the camera is a sublimation of the gun, to photograph someone is a sublimated murder—a soft murder, appropriate to a sad, frightened time.

Eventually, people might learn to act out more of their aggressions with cameras and fewer with guns, with the price being an even more image-choked world. One situation where people are switching from bullets to film is the photographic safari that is replacing the gun safari in East Africa. The hunters have Hasselblads instead of Winchesters; instead of looking through a telescopic sight to aim a rifle, they look through a viewfinder to frame a picture. In end-of-the-century London, Samuel Butler complained that "there is a photographer in every bush, going about like a roaring lion seeking whom he may devour." The photographer is now charging real beasts, beleaguered and too rare to kill. Guns have metamorphosed into cameras in this earnest comedy, the ecology safari, because nature has ceased to be what it always had been—what people needed protection from. Now nature—tamed, endangered, mortal—needs to be protected from people. When we are afraid, we shoot. But when we are nostalgic, we take pictures.

It is a nostalgic time right now, and photographs actively promote nostalgia. Photography is an elegiac art, a twilight art. Most subjects photographed are, just by virtue of being

photographed, touched with pathos. An ugly or grotesque subject may be moving because it has been dignified by the attention of the photographer. A beautiful subject can be the object of rueful feelings, because it has aged or decayed or no longer exists. All photographs are *memento mori*. To take a photograph is to participate in another person's (or thing's) mortality, vulnerability, mutability. Precisely by slicing out this moment and freezing it, all photographs testify to time's relentless melt.

Cameras began duplicating the world at that moment when the human landscape started to undergo a vertiginous rate of change: while an untold number of forms of biological and social life are being destroyed in a brief span of time, a device is available to record what is disappearing. The moody, intricately textured Paris of Atget and Brassaï is mostly gone. Like the dead relatives and friends preserved in the family album, whose presence in photographs exorcises some of the anxiety and remorse prompted by their disappearance, so the photographs of neighborhoods now torn down, rural places disfigured and made barren, supply our pocket relation to the past.

A photograph is both a pseudo-presence and a token of absence. Like a wood fire in a room, photographs—especially those of people, of distant landscapes and faraway cities, of the vanished past—are incitements to reverie. The sense of the unattainable that can be evoked by photographs feeds directly into the erotic feelings of those for whom desirability is

enhanced by distance. The lover's photograph hidden in a married woman's wallet, the poster photograph of a rock star tacked up over an adolescent's bed, the campaign-button image of a politician's face pinned on a voter's coat, the snapshots of a cabdriver's children clipped to the visor—all such talismanic uses of photographs express a feeling both sentimental and implicitly magical: they are attempts to contact or lay claim to another reality.

PHOTOGRAPHS CAN ABET DESIRE in the most direct, utilitarian way—as when someone collects photographs of anonymous examples of the desirable as an aid to masturbation. The matter is more complex when photographs are used to stimulate the moral impulse. Desire has no history—at least, it is experienced in each instance as all foreground, immediacy. It is aroused by archetypes and is, in that sense, abstract. But moral feelings are embedded in history, whose personae are concrete, whose situations are always specific. Thus, almost opposite rules hold true for the use of the photograph to awaken desire and to awaken conscience. The images that mobilize conscience are always linked to a given historical situation. The more general they are, the less likely they are to be effective.

A photograph that brings news of some unsuspected zone of misery cannot make a dent in public opinion unless there is an appropriate context of feeling and attitude. The photographs Mathew Brady and his colleagues took of the horrors

of the battlefields did not make people any less keen to go on with the Civil War. The photographs of ill-clad, skeletal prisoners held at Andersonville inflamed Northern public opinion—against the South. (The effect of the Andersonville photographs must have been partly due to the very novelty, at that time, of seeing photographs.) The political understanding that many Americans came to in the 1960s would allow them, looking at the photographs Dorothea Lange took of Nisei on the West Coast being transported to internment camps in 1942, to recognize their subject for what it was—a crime committed by the government against a large group of American citizens. Few people who saw those photographs in the 1940s could have had so unequivocal a reaction; the grounds for such a judgment were covered over by the pro-war consensus. Photographs cannot create a moral position, but they can reinforce one—and can help build a nascent one.

Photographs may be more memorable than moving images, because they are a neat slice of time, not a flow. Television is a stream of underselected images, each of which cancels its predecessor. Each still photograph is a privileged moment, turned into a slim object that one can keep and look at again. Photographs like the one that made the front page of most newspapers in the world in 1972—a naked South Vietnamese child just sprayed by American napalm, running down a highway toward the camera, her arms open, screaming with pain—probably did more to increase the public

revulsion against the war than a hundred hours of televised barbarities.

One would like to imagine that the American public would not have been so unanimous in its acquiescence to the Korean War if it had been confronted with photographic evidence of the devastation of Korea, an ecocide and genocide in some respects even more thorough than those inflicted on Vietnam a decade later. But the supposition is trivial. The public did not see such photographs because there was, ideologically, no space for them. No one brought back photographs of daily life in Pyongyang, to show that the enemy had a human face, as Felix Greene and Marc Riboud brought back photographs of Hanoi. Americans did have access to photographs of the suffering of the Vietnamese (many of which came from military sources and were taken with quite a different use in mind) because journalists felt backed in their efforts to obtain those photographs, the event having been defined by a significant number of people as a savage colonialist war. The Korean War was understood differently—as part of the just struggle of the Free World against the Soviet Union and China—and, given that characterization, photographs of the cruelty of unlimited American firepower would have been irrelevant.

Though an event has come to mean, precisely, something worth photographing, it is still ideology (in the broadest sense) that determines what constitutes an event. There can be no evidence, photographic or otherwise, of an event until the event itself has been named and characterized. And it is never

photographic evidence which can construct—more properly, identify—events; the contribution of photography always follows the naming of the event. What determines the possibility of being affected morally by photographs is the existence of a relevant political consciousness. Without a politics, photographs of the slaughter-bench of history will most likely be experienced as, simply, unreal or as a demoralizing emotional blow.

The quality of feeling, including moral outrage, that people can muster in response to photographs of the oppressed, the exploited, the starving, and the massacred also depends on the degree of their familiarity with these images. Don McCullin's photographs of emaciated Biafrans in the early 1970s had less impact for some people than Werner Bischof's photographs of Indian famine victims in the early 1950s because those images had become banal, and the photographs of Tuareg families dying of starvation in the sub-Sahara that appeared in magazines everywhere in 1973 must have seemed to many like an unbearable replay of a now familiar atrocity exhibition.

Photographs shock insofar as they show something novel. Unfortunately, the ante keeps getting raised—partly through the very proliferation of such images of horror. One's first encounter with the photographic inventory of ultimate horror is a kind of revelation, the prototypically modern revelation: a negative epiphany. For me, it was photographs of Bergen-Belsen and Dachau which I came across by chance in a

bookstore in Santa Monica in July 1945. Nothing I have seen—in photographs or in real life—ever cut me as sharply, deeply, instantaneously. Indeed, it seems plausible to me to divide my life into two parts, before I saw those photographs (I was twelve) and after, though it was several years before I understood fully what they were about. What good was served by seeing them? They were only photographs—of an event I had scarcely heard of and could do nothing to affect, of suffering I could hardly imagine and could do nothing to relieve. When I looked at those photographs, something broke. Some limit had been reached, and not only that of horror; I felt irrevocably grieved, wounded, but a part of my feelings started to tighten; something went dead; something is still crying.

To suffer is one thing; another thing is living with the photographed images of suffering, which does not necessarily strengthen conscience and the ability to be compassionate. It can also corrupt them. Once one has seen such images, one has started down the road of seeing more—and more. Images transfix. Images anesthetize. An event known through photographs certainly becomes more real than it would have been if one had never seen the photographs—think of the Vietnam War. (For a counter-example, think of the Gulag Archipelago, of which we have no photographs.) But after repeated exposure to images it also becomes less real.

The same law holds for evil as for pornography. The shock of photographed atrocities wears off with repeated viewings, just as the surprise and bemusement felt the first time one

sees a pornographic movie wear off after one sees a few more. The sense of taboo which makes us indignant and sorrowful is not much sturdier than the sense of taboo that regulates the definition of what is obscene. And both have been sorely tried in recent years. The vast photographic catalogue of misery and injustice throughout the world has given everyone a certain familiarity with atrocity, making the horrible seem more ordinary—making it appear familiar, remote ("it's only a photograph"), inevitable. At the time of the first photographs of the Nazi camps, there was nothing banal about these images. After thirty years, a saturation point may have been reached. In these last decades, "concerned" photography has done at least as much to deaden conscience as to arouse it.

The ethical content of photographs is fragile. With the possible exception of photographs of those horrors, like the Nazi camps, that have gained the status of ethical reference points, most photographs do not keep their emotional charge. A photograph of 1900 that was affecting then because of its subject would, today, be more likely to move us because it is a photograph taken in 1900. The particular qualities and intentions of photographs tend to be swallowed up in the generalized pathos of time past. Aesthetic distance seems built into the very experience of looking at photographs, if not right away, then certainly with the passage of time. Time eventually positions most photographs, even the most amateurish, at the level of art.

*

THE INDUSTRIALIZATION OF PHOTOGRAPHY permitted its rapid absorption into rational—that is, bureaucratic—ways of running society. No longer toy images, photographs became part of the general furniture of the environment—touchstones and confirmations of that reductive approach to reality which is considered realistic. Photographs were enrolled in the service of important institutions of control, notably the family and the police, as symbolic objects and as pieces of information. Thus, in the bureaucratic cataloguing of the world, many important documents are not valid unless they have, affixed to them, a photograph-token of the citizen's face.

The "realistic" view of the world compatible with bureaucracy redefines knowledge—as techniques and information. Photographs are valued because they give information. They tell one what there is; they make an inventory. To spies, meteorologists, coroners, archaeologists, and other information professionals, their value is inestimable. But in the situations in which most people use photographs, their value as information is of the same order as fiction. The information that photographs can give starts to seem very important at that moment in cultural history when everyone is thought to have a right to something called news. Photographs were seen as a way of giving information to people who do not take easily to reading. The *Daily News* still calls itself "New York's Picture Newspaper," its bid for populist identity. At the opposite end of the scale, *Le Monde*, a newspaper designed for skilled, well-informed readers, runs no photographs at all. The presumption

is that, for such readers, a photograph could only illustrate the analysis contained in an article.

A new sense of the notion of information has been constructed around the photographic image. The photograph is a thin slice of space as well as time. In a world ruled by photographic images, all borders ("framing") seem arbitrary. Anything can be separated, can be made discontinuous, from anything else. All that is necessary is to frame the subject differently. (Conversely, anything can be made adjacent to anything else.) Photography reinforces a nominalist view of social reality as consisting of small units of apparently infinite number—as the number of photographs that could be taken of anything is unlimited. Through photographs, the world becomes a series of unrelated, freestanding particles; and history, past and present, a set of anecdotes and *faits divers*. The camera makes reality atomic, manageable, and opaque. It is a view of the world which denies interconnectedness, continuity, but which confers on each moment the character of a mystery. Any photograph has multiple meanings; indeed, to see something in the form of a photograph is to encounter a potential object of fascination. The ultimate wisdom of the photographic image is to say: "There is the surface. Now think—or rather feel, intuit—what is beyond it, what the reality must be like if it looks this way." Photographs, which cannot themselves explain anything, are inexhaustible invitations to deduction, speculation, and fantasy.

Photography implies that we know about the world if we

accept it as the camera records it. But this is the opposite of understanding, which starts from *not* accepting the world as it looks. All possibility of understanding is rooted in the ability to say no. Strictly speaking, one never understands anything from a photograph. Of course, photographs fill in blanks in our mental pictures of the present and the past: for example, Jacob Riis's images of New York squalor in the 1880s are sharply instructive to those unaware that urban poverty in late-nineteenth-century America was really that Dickensian. Nevertheless, the camera's rendering of reality must always hide more than it discloses. As Brecht points out, a photograph of the Krupp works reveals virtually nothing about that organization. In contrast to the amorous relation, which is based on how something looks, understanding is based on how it functions. And functioning takes place in time, and must be explained in time. Only that which narrates can make us understand.

The limit of photographic knowledge of the world is that, while it can goad conscience, it can, finally, never be ethical or political knowledge. The knowledge gained through still photographs will always be some kind of sentimentalism, whether cynical or humanist. It will be a knowledge at bargain prices—a semblance of knowledge, a semblance of wisdom; as the act of taking pictures is a semblance of appropriation, a semblance of rape. The very muteness of what is, hypothetically, comprehensible in photographs is what constitutes their attraction and provocativeness. The omnipresence

of photographs has an incalculable effect on our ethical sensibility. By furnishing this already crowded world with a duplicate one of images, photography makes us feel that the world is more available than it really is.

Needing to have reality confirmed and experience enhanced by photographs is an aesthetic consumerism to which everyone is now addicted. Industrial societies turn their citizens into image-junkies; it is the most irresistible form of mental pollution. Poignant longings for beauty, for an end to probing below the surface, for a redemption and celebration of the body of the world—all these elements of erotic feeling are affirmed in the pleasure we take in photographs. But other, less liberating feelings are expressed as well. It would not be wrong to speak of people having a *compulsion* to photograph: to turn experience itself into a way of seeing. Ultimately, having an experience becomes identical with taking a photograph of it, and participating in a public event comes more and more to be equivalent to looking at it in photographed form. That most logical of nineteenth-century aesthetes, Mallarmé, said that everything in the world exists in order to end in a book. Today everything exists to end in a photograph.

America, Seen Through Photographs, Darkly

As Walt Whitman gazed down the democratic vistas of culture, he tried to see beyond the difference between beauty and ugliness, importance and triviality. It seemed to him servile or snobbish to make any discriminations of value, except the most generous ones. Great claims were made for candor by our boldest, most delirious prophet of cultural revolution. Nobody would fret about beauty and ugliness, he implied, who was accepting a sufficiently large embrace of the real, of the inclusiveness and vitality of actual American experience. All facts, even mean ones, are incandescent in Whitman's America—that ideal space, made real by history, where "as they emit themselves facts are showered with light."

The Great American Cultural Revolution heralded in the preface to the first edition of *Leaves of Grass* (1855) didn't break out, which has disappointed many but surprised none. One great poet alone cannot change the moral weather; even when the poet has millions of Red Guards at his disposal, it is still not easy. Like every seer of cultural revolution, Whitman thought he discerned art already being overtaken, and demystified, by reality. "The United States themselves are essentially

the greatest poem." But when no cultural revolution occurred, and the greatest of poems seemed less great in days of Empire than it had under the Republic, only other artists took seriously Whitman's program of populist transcendence, of the democratic transvaluation of beauty and ugliness, importance and triviality. Far from having been themselves demystified by reality, the American arts—notably photography—now aspired to do the demystifying.

IN PHOTOGRAPHY'S EARLY DECADES, photographs were expected to be idealized images. This is still the aim of most amateur photographers, for whom a beautiful photograph is a photograph of something beautiful, like a woman, a sunset. In 1915 Edward Steichen photographed a milk bottle on a tenement fire escape, an early example of a quite different idea of the beautiful photograph. And since the 1920s, ambitious professionals, those whose work gets into museums, have steadily drifted away from lyrical subjects, conscientiously exploring plain, tawdry, or even vapid material. In recent decades, photography has succeeded in somewhat revising, for everybody, the definitions of what is beautiful and ugly—along the lines that Whitman had proposed. If (in Whitman's words) "each precise object or condition or combination or process exhibits a beauty," it becomes superficial to single out some things as beautiful and others as not. If "all that a person does or thinks is of consequence," it becomes arbitrary to treat some moments in life as important and most as trivial.

To photograph is to confer importance. There is probably no subject that cannot be beautified; moreover, there is no way to suppress the tendency inherent in all photographs to accord value to their subjects. But the meaning of value itself can be altered—as it has been in the contemporary culture of the photographic image which is a parody of Whitman's evangel. In the mansions of pre-democratic culture, someone who gets photographed is a celebrity. In the open fields of American experience, as catalogued with passion by Whitman and as sized up with a shrug by Warhol, everybody is a celebrity. No moment is more important than any other moment; no person is more interesting than any other person.

The epigraph for a book of Walker Evans's photographs published by the Museum of Modern Art is a passage from Whitman that sounds the theme of American photography's most prestigious quest:

I do not doubt but the majesty & beauty of the world are latent in any iota of the world . . . I do not doubt there is far more in trivialities, insects, vulgar persons, slaves, dwarfs, weeds, rejected refuse, than I have supposed . . .

Whitman thought he was not abolishing beauty but generalizing it. So, for generations, did the most gifted American photographers, in their polemical pursuit of the trivial and the vulgar. But among American photographers who have

matured since World War II, the Whitmanesque mandate to record in its entirety the extravagant candors of actual American experience has gone sour. In photographing dwarfs, you don't get majesty & beauty. You get dwarfs.

Starting from the images reproduced and consecrated in the sumptuous magazine *Camera Work* that Alfred Stieglitz published from 1903 to 1917 and exhibited in the gallery he ran in New York from 1905 to 1917 at 291 Fifth Avenue (first called the Little Gallery of the Photo-Secession, later simply "291")—magazine and gallery constituting the most ambitious forum of Whitmanesque judgments—American photography has moved from affirmation to erosion to, finally, a parody of Whitman's program. In this history the most edifying figure is Walker Evans. He was the last great photographer to work seriously and assuredly in a mood deriving from Whitman's euphoric humanism, summing up what had gone on before (for instance, Lewis Hine's stunning photographs of immigrants and workers), anticipating much of the cooler, ruder, bleaker photography that has been done since—as in the prescient series of "secret" photographs of anonymous New York subway riders that Evans took with a concealed camera between 1939 and 1941. But Evans broke with the heroic mode in which the Whitmanesque vision had been propagandized by Stieglitz and his disciples, who had condescended to Hine. Evans found Stieglitz's work arty.

Like Whitman, Stieglitz saw no contradiction between making art an instrument of identification with the community

and aggrandizing the artist as a heroic, romantic, self-expressing ego. In his florid, brilliant book of essays, *Port of New York* (1924), Paul Rosenfeld hailed Stieglitz as one "of the great affirmers of life. There is no matter in all the world so homely, trite, and humble that through it this man of the black box and chemical bath cannot express himself entire." Photographing, and thereby redeeming the homely, trite, and humble, is also an ingenious means of individual expression. "The photographer," Rosenfeld writes of Stieglitz, "has cast the artist's net wider into the material world than any man before him or alongside him." Photography is a kind of over-statement, a heroic copulation with the material world. Like Hine, Evans sought a more impersonal kind of affirmation, a noble reticence, a lucid understatement. Neither in the impersonal architectural still lifes of American façades and inventories of rooms that he loved to make, nor in the exact-ing portraits of Southern sharecroppers he took in the late 1930s (published in the book done with James Agee, *Let Us Now Praise Famous Men*), was Evans trying to express himself.

Even without the heroic inflection, Evans's project still descends from Whitman's: the leveling of discriminations between the beautiful and the ugly, the important and the trivial. Each thing or person photographed becomes—a photograph; and becomes, therefore, morally equivalent to any other of his photographs. Evans's camera brought out the same formal beauty in the exteriors of Victorian houses in Boston in the early 1930s as in the store buildings on main

streets in Alabama towns in 1936. But this was a leveling up, not down. Evans wanted his photographs to be "literate, authoritative, transcendent." The moral universe of the 1930s being no longer ours, these adjectives are barely credible today. Nobody demands that photography be literate. Nobody can imagine how it could be authoritative. Nobody understands how anything, least of all a photograph, could be transcendent.

Whitman preached empathy, concord in discord, oneness in diversity. Psychic intercourse with everything, everybody—plus sensual union (when he could get it)—is the giddy trip that is proposed explicitly, over and over and over, in the prefaces and the poems. This longing to proposition the whole world also dictated his poetry's form and tone. Whitman's poems are a psychic technology for chanting the reader into a new state of being (a microcosm of the "new order" envisaged for the polity); they are functional, like mantras—ways of transmitting charges of energy. The repetition, the bombastic cadence, the run-on lines, and the pushy diction are a rush of secular afflatus, meant to get readers psychically airborne, to boost them up to that height where they can identify with the past and with the community of American desire. But this message of identification with other Americans is foreign to our temperament now.

THE LAST SIGH OF the Whitmanesque erotic embrace of the nation, but universalized and stripped of all demands, was

heard in the "Family of Man" exhibit organized in 1955 by Edward Steichen, Stieglitz's contemporary and co-founder of Photo-Secession. Five hundred and three photographs by two hundred and seventy-three photographers from sixty-eight countries were supposed to converge—to prove that humanity is "one" and that human beings, for all their flaws and villainies, are attractive creatures. The people in the photographs were of all races, ages, classes, physical types. Many of them had exceptionally beautiful bodies; some had beautiful faces. As Whitman urged the readers of his poems to identify with him and with America, Steichen set up the show to make it possible for each viewer to identify with a great many of the people depicted and, potentially, with the subject of every photograph: citizens of World Photography all.

It was not until seventeen years later that photography again attracted such crowds at the Museum of Modern Art: for the retrospective given Diane Arbus's work in 1972. In the Arbus show, a hundred and twelve photographs all taken by one person and all similar—that is, everyone in them looks (in some sense) the same—imposed a feeling exactly contrary to the reassuring warmth of Steichen's material. Instead of people whose appearance pleases, representative folk doing their human thing, the Arbus show lined up assorted monsters and borderline cases—most of them ugly; wearing grotesque or unflattering clothing; in dismal or barren surroundings—who have paused to pose and, often, to gaze frankly, confidentially at the viewer. Arbus's work does not invite viewers to

identify with the pariahs and miserable-looking people she photographed. Humanity is not "one."

The Arbus photographs convey the anti-humanist message which people of good will in the 1970s are eager to be troubled by, just as they wished, in the 1950s, to be consoled and distracted by a sentimental humanism. There is not as much difference between these messages as one might suppose. The Steichen show was an up and the Arbus show was a down, but either experience serves equally well to rule out a historical understanding of reality.

Steichen's choice of photographs assumes a human condition or a human nature shared by everybody. By purporting to show that individuals are born, work, laugh, and die everywhere in the same way, "The Family of Man" denies the determining weight of history—of genuine and historically embedded differences, injustices, and conflicts. Arbus's photographs undercut politics just as decisively, by suggesting a world in which everybody is an alien, hopelessly isolated, immobilized in mechanical, crippled identities and relationships. The pious uplift of Steichen's photograph anthology and the cool dejection of the Arbus retrospective both render history and politics irrelevant. One does so by universalizing the human condition, into joy; the other by atomizing it, into horror.

The most striking aspect of Arbus's work is that she seems to have enrolled in one of art photography's most vigorous enterprises—concentrating on victims, on the unfortunate— but without the compassionate purpose that such a project

is expected to serve. Her work shows people who are pathetic, pitiable, as well as repulsive, but it does not arouse any compassionate feelings. For what would be more correctly described as their dissociated point of view, the photographs have been praised for their candor and for an unsentimental empathy with their subjects. What is actually their aggressiveness toward the public has been treated as a moral accomplishment: that the photographs don't allow the viewer to be distant from the subject. More plausibly, Arbus's photographs—with their acceptance of the appalling—suggest a naïveté which is both coy and sinister, for it is based on distance, on privilege, on a feeling that what the viewer is asked to look at is really *other*. Buñuel, when asked once why he made movies, said that it was "to show that this is not the best of all possible worlds." Arbus took photographs to show something simpler—that there is another world.

The other world is to be found, as usual, inside this one. Avowedly interested only in photographing people who "looked strange," Arbus found plenty of material close to home. New York, with its drag balls and welfare hotels, was rich with freaks. There was also a carnival in Maryland, where Arbus found a human pincushion, a hermaphrodite with a dog, a tattooed man, and an albino sword-swallower; nudist camps in New Jersey and in Pennsylvania; Disneyland and a Hollywood set, for their dead or fake landscapes without people; and the unidentified mental hospital where she took some of her last, and most disturbing, photographs.

And there was always daily life, with its endless supply of oddities—if one has the eye to see them. The camera has the power to catch so-called normal people in such a way as to make them look abnormal. The photographer chooses oddity, chases it, frames it, develops it, titles it.

"You see someone on the street," Arbus wrote, "and essentially what you notice about them is the flaw." The insistent sameness of Arbus's work, however far she ranges from her prototypical subjects, shows that her sensibility, armed with a camera, could insinuate anguish, kinkiness, mental illness with any subject. Two photographs are of crying babies; the babies look disturbed, crazy. Resembling or having something in common with someone else is a recurrent source of the ominous, according to the characteristic norms of Arbus's dissociated way of seeing. It may be two girls (not sisters) wearing identical raincoats whom Arbus photographed together in Central Park; or the twins and triplets who appear in several pictures. Many photographs point with oppressive wonder to the fact that two people form a couple; and every couple is an odd couple: straight or gay, black or white, in an old-age home or in a junior high. People looked eccentric because they didn't wear clothes, like nudists; or because they did, like the waitress in the nudist camp who's wearing an apron. Anybody Arbus photographed was a freak—a boy waiting to march in a pro-war parade, wearing his straw boater and his "Bomb Hanoi" button; the King and Queen of a Senior Citizens

Dance; a thirtyish suburban couple sprawled in their lawn chairs; a widow sitting alone in her cluttered bedroom. In "A Jewish giant at home with his parents in the Bronx, NY, 1970," the parents look like midgets, as wrong-sized as the enormous son hunched over them under their low living-room ceiling.

The authority of Arbus's photographs derives from the contrast between their lacerating subject matter and their calm, matter-of-fact attentiveness. This quality of attention—the attention paid by the photographer, the attention paid by the subject to the act of being photographed—creates the moral theater of Arbus's straight-on, contemplative portraits. Far from spying on freaks and pariahs, catching them unawares, the photographer has gotten to know them, reassured them—so that they posed for her as calmly and stiffly as any Victorian notable sat for a studio portrait by Julia Margaret Cameron. A large part of the mystery of Arbus's photographs lies in what they suggest about how her subjects felt after consenting to be photographed. Do they see themselves, the viewer wonders, like *that?* Do they know how grotesque they are? It seems as if they don't.

The subject of Arbus's photographs is, to borrow the stately Hegelian label, "the unhappy consciousness." But most characters in Arbus's Grand Guignol appear not to know that they are ugly. Arbus photographs people in various degrees of unconscious or unaware relation to their pain, their ugliness. This necessarily limits what kinds of horrors she might have

been drawn to photograph: it excludes sufferers who presumably know they are suffering, like victims of accidents, wars, famines, and political persecutions. Arbus would never have taken pictures of accidents, events that break into a life; she specialized in slow-motion private smashups, most of which had been going on since the subject's birth.

Though most viewers are ready to imagine that these people, the citizens of the sexual underworld as well as the genetic freaks, are unhappy, few of the pictures actually show emotional distress. The photographs of deviates and real freaks do not accent their pain but, rather, their detachment and autonomy. The female impersonators in their dressing rooms, the Mexican dwarf in his Manhattan hotel room, the Russian midgets in a living room on 100th Street, and their kin are mostly shown as cheerful, self-accepting, matter-of-fact. Pain is more legible in the portraits of the normals: the quarreling elderly couple on a park bench, the New Orleans lady bartender at home with a souvenir dog, the boy in Central Park clenching his toy hand grenade.

Brassaï denounced photographers who try to trap their subjects off-guard, in the erroneous belief that something special will be revealed about them.* In the world colonized

*Not an error, really. There is something on people's faces when they don't know they are being observed that never appears when they do. If we did not know how Walker Evans took his subway photographs (riding the New York subways for hundreds of hours, standing, with the lens of his camera peering between two buttons of his topcoat), it would be

by Arbus, subjects are always revealing themselves. There is no decisive moment. Arbus's view that self-revelation is a continuous, evenly distributed process is another way of maintaining the Whitmanesque imperative: treat all moments as of equal consequence. Like Brassaï, Arbus wanted her subjects to be as fully conscious as possible, aware of the act in which they were participating. Instead of trying to coax her subjects into a natural or typical position, they are encouraged to be awkward—that is, to pose. (Thereby, the revelation of self gets identified with what is strange, odd, askew.) Standing or sitting stiffly makes them seem like images of themselves.

Most Arbus pictures have the subjects looking straight into the camera. This often makes them look even odder, almost deranged. Compare the 1912 photograph by Lartigue of a woman in a plumed hat and veil ("Racecourse at Nice") with Arbus's "Woman with a Veil on Fifth Avenue, NYC, 1968." Apart from the characteristic ugliness of Arbus's subject (Lartigue's subject is, just as characteristically, beautiful), what makes the woman in Arbus's photograph strange is the bold unselfconsciousness of her pose. If the Lartigue woman looked back, she might appear almost as strange.

obvious from the pictures themselves that the seated passengers, although photographed close and frontally, didn't know they were being photographed; their expressions are private ones, not those they would offer to the camera.

In the normal rhetoric of the photographic portrait, facing the camera signifies solemnity, frankness, the disclosure of the subject's essence. That is why frontality seems right for ceremonial pictures (like weddings, graduations) but less apt for photographs used on billboards to advertise political candidates. (For politicians the three-quarter gaze is more common: a gaze that soars rather than confronts, suggesting instead of the relation to the viewer, to the present, the more ennobling abstract relation to the future.) What makes Arbus's use of the frontal pose so arresting is that her subjects are often people one would not expect to surrender themselves so amiably and ingenuously to the camera. Thus, in Arbus's photographs, frontality also implies in the most vivid way the subject's cooperation. To get these people to pose, the photographer has had to gain their confidence, has had to become "friends" with them.

Perhaps the scariest scene in Tod Browning's film *Freaks* (1932) is the wedding banquet, when pinheads, bearded women, Siamese twins, and living torsos dance and sing their acceptance of the wicked normal-sized Cleopatra, who has just married the gullible midget hero. "One of us! One of us! One of us!" they chant as a loving cup is passed around the table from mouth to mouth to be finally presented to the nauseated bride by an exuberant dwarf. Arbus had a perhaps oversimple view of the charm and hypocrisy and discomfort of fraternizing with freaks. Following the elation of discovery, there was the thrill of having won their confidence, of

not being afraid of them, of having mastered one's aversion. Photographing freaks "had a terrific excitement for me," Arbus explained. "I just used to adore them."

DIANE ARBUS'S PHOTOGRAPHS WERE already famous to people who follow photography when she killed herself in 1971; but, as with Sylvia Plath, the attention her work has attracted since her death is of another order—a kind of apotheosis. The fact of her suicide seems to guarantee that her work is sincere, not voyeuristic, that it is compassionate, not cold. Her suicide also seems to make the photographs more devastating, as if it proved the photographs to have been dangerous to her.

She herself suggested the possibility. "Everything is so superb and breathtaking. I am creeping forward on my belly like they do in war movies." While photography is normally an omnipotent viewing from a distance, there is one situation in which people do get killed for taking pictures: when they photograph people killing each other. Only war photography combines voyeurism and danger. Combat photographers can't avoid participating in the lethal activity they record; they even wear military uniforms, though without rank badges. To discover (through photographing) that life is "really a melodrama," to understand the camera as a weapon of aggression, implies there will be casualties. "I'm sure there are limits," she wrote. "God knows, when the troops start advancing on you, you do approach that stricken feeling where you perfectly

well can get killed." Arbus's words in retrospect describe a kind of combat death: having trespassed certain limits, she fell in a psychic ambush, a casualty of her own candor and curiosity.

In the old romance of the artist, any person who has the temerity to spend a season in hell risks not getting out alive or coming back psychically damaged. The heroic avant-gardism of French literature in the late nineteenth and early twentieth centuries furnishes a memorable pantheon of artists who fail to survive their trips to hell. Still, there is a large difference between the activity of a photographer, which is always willed, and the activity of a writer, which may not be. One has the right to, may feel compelled to, give voice to one's own pain—which is, in any case, one's own property. One volunteers to seek out the pain of others.

Thus, what is finally most troubling in Arbus's photographs is not their subject at all but the cumulative impression of the photographer's consciousness: the sense that what is presented is precisely a private vision, something voluntary. Arbus was not a poet delving into her entrails to relate her own pain but a photographer venturing out into the world to *collect* images that are painful. And for pain sought rather than just felt, there may be a less than obvious explanation. According to Reich, the masochist's taste for pain does not spring from a love of pain but from the hope of procuring, by means of pain, a strong sensation; those handicapped by emotional or sensory analgesia only prefer pain to not feeling

anything at all. But there is another explanation of why people seek pain, diametrically opposed to Reich's that also seems pertinent: that they seek it not to feel more but to feel less.

Insofar as looking at Arbus's photographs is, undeniably, an ordeal, they are typical of the kind of art popular among sophisticated urban people right now: art that is a self-willed test of hardness. Her photographs offer an occasion to demonstrate that life's horror can be faced without squeamishness. The photographer once had to say to herself, Okay, I can accept that; the viewer is invited to make the same declaration.

Arbus's work is a good instance of a leading tendency of high art in capitalist countries: to suppress, or at least reduce, moral and sensory queasiness. Much of modern art is devoted to lowering the threshold of what is terrible. By getting us used to what, formerly, we could not bear to see or hear, because it was too shocking, painful, or embarrassing, art changes morals—that body of psychic custom and public sanctions that draws a vague boundary between what is emotionally and spontaneously intolerable and what is not. The gradual suppression of queasiness does bring us closer to a rather formal truth—that of the arbitrariness of the taboos constructed by art and morals. But our ability to stomach this rising grotesqueness in images (moving and still) and in print has a stiff price. In the long run, it works out not as a liberation of but as a subtraction from the self: a pseudo-familiarity with the horrible reinforces alienation, making one less able

to react in real life. What happens to people's feelings on first exposure to today's neighborhood pornographic film or to tonight's televised atrocity is not so different from what happens when they first look at Arbus's photographs.

The photographs make a compassionate response feel irrelevant. The point is not to be upset, to be able to confront the horrible with equanimity. But this look that is not (mainly) compassionate is a special, modern ethical construction: not hardhearted, certainly not cynical, but simply (or falsely) naïve. To the painful nightmarish reality out there, Arbus applied such adjectives as "terrific," "interesting," "incredible," "fantastic," "sensational"—the childlike wonder of the pop mentality. The camera—according to her deliberately naïve image of the photographer's quest—is a device that captures it all, that seduces subjects into disclosing their secrets, that broadens experience. To photograph people, according to Arbus, is necessarily "cruel," "mean." The important thing is not to blink.

"Photography was a license to go wherever I wanted and to do what I wanted to do," Arbus wrote. The camera is a kind of passport that annihilates moral boundaries and social inhibitions, freeing the photographer from any responsibility toward the people photographed. The whole point of photographing people is that you are not intervening in their lives, only visiting them. The photographer is supertourist, an extension of the anthropologist, visiting natives and bringing back news of their exotic doings and strange gear. The photographer is always trying to colonize new experiences or

find new ways to look at familiar subjects—to fight against boredom. For boredom is just the reverse side of fascination: both depend on being outside rather than inside a situation, and one leads to the other. "The Chinese have a theory that you pass through boredom into fascination," Arbus noted. Photographing an appalling underworld (and a desolate, plastic overworld), she had no intention of entering into the horror experienced by the denizens of those worlds. They are to remain exotic, hence "terrific." Her view is always from the outside.

"I'M VERY LITTLE DRAWN to photographing people that are known or even subjects that are known," Arbus wrote. "They fascinate me when I've barely heard of them." However drawn she was to the maimed and the ugly, it would never have occurred to Arbus to photograph Thalidomide babies or napalm victims—public horrors, deformities with sentimental or ethical associations. Arbus was not interested in ethical journalism. She chose subjects that she could believe were found, just lying about, without any values attached to them. They are necessarily ahistorical subjects, private rather than public pathology, secret lives rather than open ones.

For Arbus, the camera photographs the unknown. But unknown to whom? Unknown to someone who is protected, who has been schooled in moralistic and in prudent responses. Like Nathanael West, another artist fascinated by

the deformed and mutilated, Arbus came from a verbally skilled, compulsively health-minded, indignation-prone, well-to-do Jewish family, for whom minority sexual tastes lived way below the threshold of awareness and risk-taking was despised as another goyish craziness. "One of the things I felt I suffered from as a kid," Arbus wrote, "was that I never felt adversity. I was confined in a sense of unreality . . . And the sense of being immune was, ludicrous as it seems, a painful one." Feeling much the same discontent, West in 1927 took a job as a night clerk in a seedy Manhattan hotel. Arbus's way of procuring experience, and thereby acquiring a sense of reality, was the camera. By experience was meant, if not material adversity, at least psychological adversity—the shock of immersion in experiences that cannot be beautified, the encounter with what is taboo, perverse, evil.

Arbus's interest in freaks expresses a desire to violate her own innocence, to undermine her sense of being privileged, to vent her frustration at being safe. Apart from West, the 1930s yield few examples of this kind of distress. More typically, it is the sensibility of someone educated and middle-class who came of age between 1945 and 1955—a sensibility that was to flourish precisely in the 1960s.

The decade of Arbus's serious work coincides with, and is very much of, the sixties, the decade in which freaks went public, and became a safe, approved subject of art. What in the 1930s was treated with anguish—as in *Miss Lonely-hearts* and *The Day of the Locust*—would in the 1960s be treated in a

perfectly deadpan way, or with positive relish (in the films of Fellini, Arrabal, Jodorowsky, in underground comics, in rock spectacles). At the beginning of the sixties, the thriving Freak Show at Coney Island was outlawed; the pressure is on to raze the Times Square turf of drag queens and hustlers and cover it with skyscrapers. As the inhabitants of deviant underworlds are evicted from their restricted territories—banned as unseemly, a public nuisance, obscene, or just unprofitable—they increasingly come to infiltrate consciousness as the subject matter of art, acquiring a certain diffuse legitimacy and metaphoric proximity which creates all the more distance.

Who could have better appreciated the truth of freaks than someone like Arbus, who was by profession a fashion photographer—a fabricator of the cosmetic lie that masks the intractable inequalities of birth and class and physical appearance. But unlike Warhol, who spent many years as a commercial artist, Arbus did not make her serious work out of promoting and kidding the aesthetic of glamour to which she had been apprenticed, but turned her back on it entirely. Arbus's work is reactive—reactive against gentility, against what is approved. It was her way of saying fuck *Vogue*, fuck fashion, fuck what's pretty. This challenge takes two not wholly compatible forms. One is a revolt against the Jews' hyper-developed moral sensibility. The other revolt, itself hotly moralistic, turns against the success world. The moralist's subversion advances life as a failure as the antidote to life as a success. The aesthete's subversion, which the sixties was

to make peculiarly its own, advances life as a horror show as the antidote to life as a bore.

Most of Arbus's work lies within the Warhol aesthetic, that is, defines itself in relation to the twin poles of boringness and freakishness; but it doesn't have the Warhol style. Arbus had neither Warhol's narcissism and genius for publicity nor the self-protective blandness with which he insulates himself from the freaky nor his sentimentality. It is unlikely that Warhol, who comes from a working-class family, ever felt any of the ambivalence toward success which afflicted the children of the Jewish upper middle classes in the 1960s. To someone raised as a Catholic, like Warhol (and virtually everyone in his gang), a fascination with evil comes much more genuinely than it does to someone from a Jewish background. Compared with Warhol, Arbus seems strikingly vulnerable, innocent—and certainly more pessimistic. Her Dantesque vision of the city (and the suburbs) has no reserves of irony. Although much of Arbus's material is the same as that depicted in, say, Warhol's *Chelsea Girls* (1966), her photographs never play with horror, milking it for laughs; they offer no opening to mockery, and no possibility of finding freaks endearing, as do the films of Warhol and Paul Morrissey. For Arbus, both freaks and Middle America were equally exotic: a boy marching in a pro-war parade and a Levittown housewife were as alien as a dwarf or a transvestite; lower-middle-class suburbia was as remote as Times Square, lunatic asylums, and gay bars. Arbus's work expressed her turn against what was public

(as she experienced it), conventional, safe, reassuring—and boring—in favor of what was private, hidden, ugly, dangerous, and fascinating. These contrasts, now, seem almost quaint. What is safe no longer monopolizes public imagery. The freakish is no longer a private zone, difficult of access. People who are bizarre, in sexual disgrace, emotionally vacant are seen daily on the newsstands, on TV, in the subways. Hobbesian man roams the streets, quite visible, with glitter in his hair.

SOPHISTICATED IN THE FAMILIAR modernist way—choosing awkwardness, naïveté, sincerity over the slickness and artificiality of high art and high commerce—Arbus said that the photographer she felt closest to was Weegee, whose brutal pictures of crime and accident victims were a staple of the tabloids in the 1940s. Weegee's photographs are indeed upsetting, his sensibility is urban, but the similarity between his work and Arbus's ends there. However eager she was to disavow standard elements of photographic sophistication such as composition, Arbus was not unsophisticated. And there is nothing journalistic about her motives for taking pictures. What may seem journalistic, even sensational, in Arbus's photographs places them, rather, in the main tradition of Surrealist art—their taste for the grotesque, their professed innocence with respect to their subjects, their claim that all subjects are merely *objets trouvés*.

"I would never choose a subject for what it meant to me when I think of it," Arbus wrote, a dogged exponent of the

Surrealist bluff. Presumably, viewers are not supposed to judge the people she photographs. Of course, we do. And the very range of Arbus's subjects itself constitutes a judgment. Brassaï, who photographed people like those who interested Arbus—see his "La Môme Bijou" of 1932—also did tender cityscapes, portraits of famous artists. Lewis Hine's "Mental Institution, New Jersey, 1924" could be a late Arbus photograph (except that the pair of Mongoloid children posing on the lawn are photographed in profile rather than frontally); the Chicago street portraits Walker Evans took in 1946 are Arbus material, as are a number of photographs by Robert Frank. The difference is in the range of other subjects, other emotions that Hine, Brassaï, Evans, and Frank photographed. Arbus is an *auteur* in the most limiting sense, as special a case in the history of photography as is Giorgio Morandi, who spent a half century doing still lifes of bottles, in the history of modern European painting. She does not, like most ambitious photographers, play the field of subject matter—even a little. On the contrary, all her subjects are equivalent. And making equivalences between freaks, mad people, suburban couples, and nudists is a very powerful judgment, one in complicity with a recognizable political mood shared by many educated, left-liberal Americans. The subjects of Arbus's photographs are all members of the same family, inhabitants of a single village. Only, as it happens, the idiot village is America. Instead of showing identity between things which are different (Whitman's democratic vista), everybody is shown to look the same.

Succeeding the more buoyant hopes for America has come a bitter, sad embrace of experience. There is a particular melancholy in the American photographic project. But the melancholy was already latent in the heyday of Whitman-esque affirmation, as represented by Stieglitz and his Photo-Secession circle. Stieglitz, pledged to redeem the world with his camera, was still shocked by modern material civilization. He photographed New York in the 1910s in an almost quixotic spirit—camera/lance against skyscraper/windmill. Paul Rosenfeld described Stieglitz's efforts as a "perpetual affirmation." The Whitmanesque appetites have turned pious: the photographer now patronizes reality. One needs a camera to show patterns in that "dull and marvelous opacity called the United States."

Obviously, a mission as rotten with doubt about America—even at its most optimistic—was bound to get deflated fairly soon, as post-World War I America committed itself more boldly to big business and consumerism. Photographers with less ego and magnetism than Stieglitz gradually gave up the struggle. They might continue to practice the atomistic visual stenography inspired by Whitman. But, without Whitman's delirious powers of synthesis, what they documented was discontinuity, detritus, loneliness, greed, sterility. Stieglitz, using photography to challenge the materialist civilization, was, in Rosenfeld's words, "the man who believed that a spiritual America existed somewhere, that America was not the grave of the Occident." The implicit intent of Frank and

Arbus, and of many of their contemporaries and juniors, is to show that America *is* the grave of the Occident.

Since photography cut loose from the Whitman-esque affirmation—since it has ceased to understand how photographs could aim at being literate, authoritative, transcendent—the best of American photography (and much else in American culture) has given itself over to the consolations of Surrealism, and America has been discovered as the quintessential Surrealist country. It is obviously too easy to say that America is just a freak show, a wasteland—the cut-rate pessimism typical of the reduction of the real to the surreal. But the American partiality to myths of redemption and damnation remains one of the most energizing, most seductive aspects of our national culture. What we have left of Whitman's discredited dream of cultural revolution are paper ghosts and a sharp-eyed witty program of despair.

Melancholy Objects

Photography has the unappealing reputation of being the most realistic, therefore facile, of the mimetic arts. In fact, it is the one art that has managed to carry out the grandiose, century-old threats of a Surrealist takeover of the modern sensibility, while most of the pedigreed candidates have dropped out of the race.

Painting was handicapped from the start by being a fine art, with each object a unique, handmade original. A further liability was the exceptional technical virtuosity of those painters usually included in the Surrealist canon, who seldom imagined the canvas as other than figurative. Their paintings looked sleekly calculated, complacently well made, undialectical. They kept a long, prudent distance from Surrealism's contentious idea of blurring the lines between art and so-called life, between objects and events, between the intended and the unintentional, between pros and amateurs, between the noble and the tawdry, between craftsmanship and lucky blunders. The result was that Surrealism in painting amounted to little more than the contents of a meagerly stocked dream world: a few witty fantasies, mostly wet dreams and agoraphobic nightmares. (Only when its libertarian rhetoric helped

to nudge Jackson Pollock and others into a new kind of irreverent abstraction did the Surrealist mandate for painters finally seem to make wide creative sense.) Poetry, the other art to which the early Surrealists were particularly devoted, has yielded almost equally disappointing results. The arts in which Surrealism has come into its own are prose fiction (as content, mainly, but much more abundant and more complex thematically than that claimed by painting), theater, the arts of assemblage, and—most triumphantly—photography.

That photography is the only art that is natively surreal does not mean, however, that it shares the destinies of the official Surrealist movement. On the contrary. Those photographers (many of them ex-painters) consciously influenced by Surrealism count almost as little today as the nineteenth-century "pictorial" photographers who copied the look of Beaux-Arts painting. Even the loveliest *trouvailles* of the 1920s—the solarized photographs and Rayographs of Man Ray, the photograms of László Moholy-Nagy, the multiple-exposure studies of Bragaglia, the photomontages of John Heartfield and Alexander Rodchenko—are regarded as marginal exploits in the history of photography. The photographers who concentrated on interfering with the supposedly superficial realism of the photograph were those who most narrowly conveyed photography's surreal properties. The Surrealist legacy for photography came to seem trivial as the Surrealist repertoire of fantasies and props was rapidly absorbed into high fashion in the 1930s, and Surrealist photography offered

mainly a mannered style of portraiture, recognizable by its use of the same decorative conventions introduced by Surrealism in other arts, particularly painting, theater, and advertising. The mainstream of photographic activity has shown that a Surrealist manipulation or theatricalization of the real is unnecessary, if not actually redundant. Surrealism lies at the heart of the photographic enterprise: in the very creation of a duplicate world, of a reality in the second degree, narrower but more dramatic than the one perceived by natural vision. The less doctored, the less patently crafted, the more naïve—the more authoritative the photograph was likely to be.

Surrealism has always courted accidents, welcomed the uninvited, flattered disorderly presences. What could be more surreal than an object which virtually produces itself, and with a minimum of effort? An object whose beauty, fantastic disclosures, emotional weight are likely to be further enhanced by any accidents that might befall it? It is photography that has best shown how to juxtapose the sewing machine and the umbrella, whose fortuitous encounter was hailed by a great Surrealist poet as an epitome of the beautiful.

Unlike the fine-art objects of pre-democratic eras, photographs don't seem deeply beholden to the intentions of an artist. Rather, they owe their existence to a loose cooperation (quasi-magical, quasi-accidental) between photographer and subject—mediated by an ever simpler and more automated machine, which is tireless, and which even when capricious

can produce a result that is interesting and never entirely wrong. (The sales pitch for the first Kodak, in 1888, was: "You press the button, we do the rest." The purchaser was guaranteed that the picture would be "without any mistake.") In the fairy tale of photography the magic box insures veracity and banishes error, compensates for inexperience and rewards innocence.

The myth is tenderly parodied in a 1928 silent film, *The Cameraman*, which has an inept dreamy Buster Keaton vainly struggling with his dilapidated apparatus, knocking out windows and doors whenever he picks up his tripod, never managing to take one decent picture, yet finally getting some great footage (a photojournalist scoop of a tong war in New York's Chinatown)—by inadvertence. It is the hero's pet monkey who loads the camera with film and operates it part of the time.

THE ERROR OF THE Surrealist militants was to imagine the surreal to be something universal, that is, a matter of psychology, whereas it turns out to be what is most local, ethnic, class-bound, dated. Thus, the earliest surreal photographs come from the 1850s, when photographers first went out prowling the streets of London, Paris, and New York, looking for their unposed slice of life. These photographs, concrete, particular, anecdotal (except that the anecdote has been effaced)—moments of lost time, of vanished customs—seem far more surreal to us now than any photograph rendered

abstract and poetic by superimposition, under-printing, solar-ization, and the like. Believing that the images they sought came from the unconscious, whose contents they assumed as loyal Freudians to be timeless as well as universal, the Surrealists misunderstood what was most brutally moving, irrational, unassimilable, mysterious—time itself. What renders a photograph surreal is its irrefutable pathos as a message from time past, and the concreteness of its intimations about social class.

Surrealism is a bourgeois disaffection; that its militants thought it universal is only one of the signs that it is typically bourgeois. As an aesthetics that yearns to be a politics, Surrealism opts for the underdog, for the rights of a disestablished or unofficial reality. But the scandals flattered by Surrealist aesthetics generally turned out to be just those homely mysteries obscured by the bourgeois social order: sex and poverty. Eros, which the early Surrealists placed at the summit of the tabooed reality they sought to rehabilitate, was itself part of the mystery of social station. While it seemed to flourish luxuriantly at extreme ends of the scale, both the lower classes and the nobility being regarded as naturally libertine, middle-class people had to toil to make their sexual revolution. Class was the deepest mystery: the inexhaustible glamour of the rich and powerful, the opaque degradation of the poor and outcast.

The view of reality as an exotic prize to be tracked down and captured by the diligent hunter-with-a-camera has

informed photography from the beginning, and marks the confluence of the Surrealist counter-culture and middle-class social adventurism. Photography has always been fascinated by social heights and lower depths. Documentarists (as distinct from countries with cameras) prefer the latter. For more than a century, photographers have been hovering about the oppressed, in attendance at scenes of violence—with a spectacularly good conscience. Social misery has inspired the comfortably-off with the urge to take pictures, the gentlest of predations, in order to document a hidden reality, that is, a reality hidden from them.

Gazing on other people's reality with curiosity, with detachment, with professionalism, the ubiquitous photographer operates as if that activity transcends class interests, as if its perspective is universal. In fact, photography first comes into its own as an extension of the eye of the middle class *flâneur*, whose sensibility was so accurately charted by Baudelaire. The photographer is an armed version of the solitary walker reconnoitering, stalking, cruising the urban inferno, the voyeuristic stroller who discovers the city as a landscape of voluptuous extremes. Adept of the joys of watching, connoisseur of empathy, the *flâneur* finds the world "picturesque." The findings of Baudelaire's *flâneur* are variously exemplified by the candid snapshots taken in the 1890s by Paul Martin in London streets and at the seaside and by Arnold Genthe in San Francisco's Chinatown (both using a concealed camera), by Atget's twilight Paris of shabby streets and decaying trades,

by the dramas of sex and loneliness depicted in Brassaï's book *Paris de nuit* (1933), by the image of the city as a theater of disaster in Weegee's *Naked City* (1945). The *flâneur* is not attracted to the city's official realities but to its dark seamy corners, its neglected populations—an unofficial reality behind the façade of bourgeois life that the photographer "apprehends," as a detective apprehends a criminal.

Returning to *The Cameraman*: a tong war among poor Chinese makes an ideal subject. It is completely exotic, therefore worth photographing. Part of what assures the success of the hero's film is that he doesn't understand his subject at all. (As played by Buster Keaton, he doesn't even understand that his life is in danger.) The perennial surreal subject is *How the Other Half Lives*, to cite the innocently explicit title that Jacob Riis gave to the book of photographs of the New York poor that he brought out in 1890. Photography conceived as social documentation was an instrument of that essentially middle-class attitude, both zealous and merely tolerant, both curious and indifferent, called humanism—which found slums the most enthralling of decors. Contemporary photographers have, of course, learned to dig in and limit their subject. Instead of the chutzpa of "the other half," we get, say, *East 100th Street* (Bruce Davidson's book of Harlem photographs published in 1970). The justification is still the same, that picture-taking serves a high purpose: uncovering a hidden truth, conserving a vanishing past. (The hidden truth is, moreover, often identified with the vanishing past. Between

1874 and 1886, prosperous Londoners could subscribe to the Society for Photographing the Relics of Old London.)

Starting as artists of the urban sensibility, photographers quickly became aware that nature is as exotic as the city, rustics as picturesque as city slum dwellers. In 1897 Sir Benjamin Stone, rich industrialist and conservative MP from Birmingham, founded the National Photographic Record Association with the aim of documenting traditional English ceremonies and rural festivals which were dying out. "Every village," Stone wrote, "has a history which might be preserved by means of the camera." For a wellborn photographer of the late nineteenth century like the bookish Count Giuseppe Primoli, the street life of the underprivileged was at least as interesting as the pastimes of his fellow aristocrats: compare Primoli's photographs of King Victor Emmanuel's wedding with his photographs of the Naples poor. It required the social immobility of a photographer of genius who happened to be a small child, Jacques-Henri Lartigue, to confine subject matter to the outlandish habits of the photographer's own family and class. But essentially the camera makes everyone a tourist in other people's reality, and eventually in one's own.

Perhaps the earliest model of the sustained look downward are the thirty-six photographs in *Street Life in London* (1877–78) taken by the British traveler and photographer John Thomson. But for each photographer specializing in the poor, many more go after a wider range of exotic reality. Thomson himself had a model career of this kind. Before turning to the

poor of his own country, he had already been to see the heathen, a sojourn which resulted in his four-volume *Illustrations of China and Its People* (1873–74). And following his book on the street life of the London poor, he turned to the indoor life of the London rich: it was Thomson who, around 1880, pioneered the vogue of at-home photographic portraiture.

From the beginning, professional photography typically meant the broader kind of class tourism, with most photographers combining surveys of social abjection with portraits of celebrities or commodities (high fashion, advertising) or studies of the nude. Many of the exemplary photographic careers of this century (like those of Edward Steichen, Bill Brandt, Henri Cartier-Bresson, Richard Avedon) proceed by abrupt changes in the social level and ethical importance of subject matter. Perhaps the most dramatic break is that between the pre-war and the post-war work of Bill Brandt. To have gone from the tough-minded photographs of Depression squalor in northern England to his stylish celebrity portraits and semi-abstract nudes of the last decades seems a long journey indeed. But there is nothing particularly idiosyncratic, or perhaps even inconsistent, in these contrasts. Traveling between degraded and glamorous realities is part of the very momentum of the photographic enterprise, unless the photographer is locked into an extremely private obsession (like the thing Lewis Carroll had for little girls or Diane Arbus had for the Halloween crowd).

Poverty is no more surreal than wealth; a body clad in

filthy rags is not more surreal than a principessa dressed for a ball or a pristine nude. What is surreal is the distance imposed, and bridged, by the photograph: the social distance and the distance in time. Seen from the middle-class perspective of photography, celebrities are as intriguing as pariahs. Photographers need not have an ironic, intelligent attitude toward their stereotyped material. Pious, respectful fascination may do just as well, especially with the most conventional subjects.

Nothing could be farther from, say, the subtleties of Avedon than the work of Ghitta Carell, Hungarian-born photographer of the celebrities of the Mussolini era. But her portraits now look as eccentric as Avedon's, and far more surreal than Cecil Beaton's Surrealist-influenced photographs from the same period. By setting his subjects—see the photographs he took of Edith Sitwell in 1927, of Cocteau in 1936—in fanciful, luxurious decors, Beaton turns them into overexplicit, unconvincing effigies. But Carell's innocent complicity with the wish of her Italian generals and aristocrats and actors to appear static, poised, glamorous exposes a hard, accurate truth about them. The photographer's reverence has made them interesting; time has made them harmless, all too human.

SOME PHOTOGRAPHERS SET UP as scientists, others as moralists. The scientists make an inventory of the world; the moralists concentrate on hard cases. An example of photography-as-science is the project August Sander began in

1911: a photographic catalogue of the German people. In contrast to George Grosz's drawings, which summed up the spirit and variety of social types in Weimar Germany through caricature, Sander's "archetype pictures" (as he called them) imply a pseudo-scientific neutrality similar to that claimed by the covertly partisan typological sciences that sprang up in the nineteenth century like phrenology, criminology, psychiatry, and eugenics. It was not so much that Sander chose individuals for their representative character as that he assumed, correctly, that the camera cannot help but reveal faces as social masks. Each person photographed was a sign of a certain trade, class, or profession. All his subjects are representative, equally representative, of a given social reality—their own.

Sander's look is not unkind; it is permissive, unjudging. Compare his 1930 photograph "Circus People" with Diane Arbus's studies of circus people or with the portraits of demimonde characters by Lisette Model. People face Sander's camera, as they do in Model's and Arbus's photographs, but their gaze is not intimate, revealing. Sander was not looking for secrets; he was observing the typical. Society contains no mystery. Like Eadweard Muybridge, whose photographic studies in the 1880s managed to dispel misconceptions about what everybody had always seen (how horses gallop, how people move) because he had subdivided the subject's movements into a precise and lengthy enough sequence of shots, Sander aimed to shed light on the social order by atomizing

it, into an indefinite number of social types. It doesn't seem surprising that in 1934, five years after its publication, the Nazis impounded the unsold copies of Sander's book *Antlitz der Zeit (The Face of Our Time)* and destroyed the printing blocks, thus bringing his national-portrait project to an abrupt end. (Sander, who stayed in Germany throughout the Nazi period, switched to landscape photography.) The charge was that Sander's project was anti-social. What might well have seemed anti-social to Nazis was his idea of the photographer as an impassive census-taker, the completeness of whose record would render all commentary, or even judgment, superfluous.

Unlike most photography with a documentary intention, enthralled either by the poor and unfamiliar, as preeminently photographable subjects, or by celebrities, Sander's social sample is unusually, conscientiously broad. He includes bureaucrats and peasants, servants and society ladies, factory workers and industrialists, soldiers and gypsies, actors and clerks. But such variety does not rule out class condescension. Sander's eclectic style gives him away. Some photographs are casual, fluent, naturalistic; others are naïve and awkward. The many posed photographs taken against a flat white background are a cross between superb mug shots and old-fashioned studio portraits. Unselfconsciously, Sander adjusted his style to the social rank of the person he was photographing. Professionals and the rich tend to be photographed indoors, without props. They speak for themselves. Laborers

and derelicts are usually photographed in a setting (often out-doors) which locates them, which speaks for them—as if they could not be assumed to have the kinds of separate identities normally achieved in the middle and upper classes.

In Sander's work everybody is in place, nobody is lost or cramped or off-center. A cretin is photographed in exactly the same dispassionate way as a bricklayer, a legless World War I veteran like a healthy young soldier in uniform, scowling Communist students like smiling Nazis, a captain of industry like an opera singer. "It is not my intention either to criticize or describe these people," Sander said. While one might have expected that he would have claimed not to have criticized his subjects, by photographing them, it is interesting that he thought he hadn't described them either. Sander's complicity with everybody also means a distance from everybody. His complicity with his subjects is not naïve (like Carell's) but nihilistic. Despite its class realism, it is one of the most truly abstract bodies of work in the history of photography.

It is hard to imagine an American attempting an equivalent of Sander's comprehensive taxonomy. The great photographic portraits of America—like Walker Evans's *American Photographs* (1938) and Robert Frank's *The Americans* (1959)—have been delib-erately random, while continuing to reflect the traditional relish of documentary photography for the poor and the dispossessed, the nation's forgotten citizens. And the most ambitious collect-ive photographic project ever undertaken in this country, by the Farm Security Administration in 1935, under the direction of

Roy Emerson Stryker, was concerned exclusively with "low-income groups."* The FSA project, conceived as "a pictorial documentation of our rural areas and rural problems" (Stryker's words), was unabashedly propagandistic, with Stryker coaching his team about the attitude they were to take toward their problem subject. The purpose of the project was to demonstrate the value of the people photographed. Thereby, it implicitly defined its point of view: that of middle-class people who needed to be convinced that the poor were really poor, and that the poor were dignified. It is instructive to compare the FSA photographs with those by Sander. Though the poor do not lack dignity in Sander's photographs, it is not because of any compassionate intentions. They have dignity by juxtaposition, because they are looked at in the same cool way as everybody else.

American photography was rarely so detached. For an approach reminiscent of Sander's, one must look to people who documented a dying or superseded part of America—like Adam Clark Vroman, who photographed Indians in

*Though that changed, as is indicated in a memo from Stryker to his staff in 1942, when the new morale needs of World War II made the poor too downbeat a subject. *"We must have at once pictures of men, women and children who appear as if they really believed in the U.S. Get people with a little spirit. Too many in our file now paint the U.S. as an old person's home and that just about everybody is too old to work and too malnourished to care much what happens . . . We particularly need young men and women who work in our factories . . . Housewives in their kitchen or in their yard picking flowers. More contented-looking old couples . . ."*

Arizona and New Mexico between 1895 and 1904. Vroman's handsome photographs are unexpressive, uncondescending, unsentimental. Their mood is the very opposite of the FSA photographs: they are not moving, they are not idiomatic, they do not invite sympathy They make no propaganda for the Indians. Sander didn't know he was photographing a disappearing world. Vroman did. He also knew that there was no saving the world that he was recording.

PHOTOGRAPHY IN EUROPE WAS largely guided by notions of the picturesque (i.e., the poor, the foreign, the time-worn), the important (i.e., the rich, the famous), and the beautiful. Photographs tended to praise or to aim at neutrality. Americans, less convinced of the permanence of any basic social arrangements, experts on the "reality" and inevitability of change, have more often made photography partisan. Pictures got taken not only to show what should be admired but to reveal what needs to be confronted, deplored—and fixed up. American photography implies a more summary, less stable connection with history; and a relation to geographic and social reality that is both more hopeful and more predatory.

The hopeful side is exemplified in the well-known use of photographs in America to awaken conscience. At the beginning of the century Lewis Hine was appointed staff photographer to the National Child Labor Committee, and his photographs of children working in cotton mills, beet fields, and coal mines did influence legislators to make child

labor illegal. During the New Deal, Stryker's FSA project (Stryker was a pupil of Hine's) brought back information about migrant workers and sharecroppers to Washington, so that bureaucrats could figure out how to help them. But even at its most moralistic, documentary photography was also imperious in another sense. Both Thomson's detached traveler's report and the impassioned muckraking of Riis or Hine reflect the urge to appropriate an alien reality. And no reality is exempt from appropriation, neither one that is scandalous (and should be corrected) nor one that is merely beautiful (or could be made so by the camera). Ideally, the photographer was able to make the two realities cognate, as illustrated by the title of an interview with Hine in 1920, "Treating Labor Artistically."

The predatory side of photography is at the heart of the alliance, evident earlier in the United States than anywhere else, between photography and tourism. After the opening of the West in 1869 by the completion of the transcontinental railroad came the colonization through photography. The case of the American Indians is the most brutal. Discreet, serious amateurs like Vroman had been operating since the end of the Civil War. They were the vanguard of an army of tourists who arrived by the end of the century, eager for "a good shot" of Indian life. The tourists invaded the Indians' privacy, photographing holy objects and the sacred dances and places, if necessary paying the Indians to pose and getting them to revise their ceremonies to provide more photogenic material.

But the native ceremony that is changed when the tourist hordes come sweeping down is not so different from a scandal in the inner city that is corrected after someone photographs it. Insofar as the muckrakers got results, they too altered what they photographed; indeed, photographing something became a routine part of the procedure for altering it. The danger was of a token change—limited to the narrowest reading of the photograph's subject. The particular New York slum, Mulberry Bend, that Riis photographed in the late 1880s was subsequently torn down and its inhabitants rehoused by order of Theodore Roosevelt, then state governor, while other, equally dreadful slums were left standing.

The photographer both loots and preserves, denounces and consecrates. Photography expresses the American impatience with reality, the taste for activities whose instrumentality is a machine. "Speed is at the bottom of it all," as Hart Crane said (writing about Stieglitz in 1923), "the hundredth of a second caught so precisely that the motion is continued from the picture indefinitely: the moment made eternal." Faced with the awesome spread and alienness of a newly settled continent, people wielded cameras as a way of taking possession of the places they visited. Kodak put signs at the entrances of many towns listing what to photograph. Signs marked the places in national parks where visitors should stand with their cameras.

Sander is at home in his own country. American photographers are often on the road, overcome with disrespectful

wonder at what their country offers in the way of surreal surprises. Moralists and conscienceless despoilers, children and foreigners in their own land, they will get something down that is disappearing—and, often, hasten its disappearance by photographing it. To take, like Sander, specimen after specimen, seeking an ideally complete inventory, presupposes that society can be envisaged as a comprehensible totality. European photographers have assumed that society has something of the stability of nature. Nature in America has always been suspect, on the defensive, cannibalized by progress. In America, every specimen becomes a relic.

The American landscape has always seemed too varied, immense, mysterious, fugitive to lend itself to scientism. "He doesn't *know*, he can't *say*, before the facts," Henry James wrote in *The American Scene* (1907),

and he doesn't even want to know or to say; the facts themselves loom, before the understanding, in too large a mass for a mere mouthful: it is as if the syllables were too numerous to make a legible word. The *i*llegible word, accordingly, the great inscrutable answer to questions, hangs in the vast American sky, to his imagination, as something fantastic and *abracadabrant*, belonging to no known language, and it is under this convenient ensign that he travels and considers and contemplates, and, to the best of his ability, enjoys.

Americans feel the reality of their country to be so stupendous, and mutable, that it would be the rankest presumption

to approach it in a classifying, scientific way. One could get at it indirectly, by subterfuge—breaking it off into strange fragments that could somehow, by synecdoche, be taken for the whole.

American photographers (like American writers) posit something ineffable in the national reality—something, possibly, that has never been seen before. Jack Kerouac begins his introduction to Robert Frank's book *The Americans*:

That crazy feeling in America when the sun is hot on the streets and music comes out of the jukebox or from a nearby funeral, that's what Robert Frank has captured in these tremendous photographs taken as he travelled on the road around practically forty-eight states in an old used car (on Guggenheim Fellowship) and with the agility, mystery, genius, sadness and strange secrecy of a shadow photographed scenes that have never been seen on film . . . After seeing these pictures you end up finally not knowing any more whether a jukebox is sadder than a coffin.

Any inventory of America is inevitably anti-scientific, a delirious "abracadabrant" confusion of objects, in which jukeboxes resemble coffins. James at least managed to make the wry judgment that "this particular effect of the scale of things is the only effect that, throughout the land, is not directly adverse to joy." For Kerouac—for the main tradition of American photography—the prevailing mood is sadness. Behind the ritualized claims of American photographers to be looking

around, at random, without preconceptions—lighting on subjects, phlegmatically recording them—is a mournful vision of loss.

The effectiveness of photography's statement of loss depends on its steadily enlarging the familiar iconography of mystery, mortality, transience. More traditional ghosts are summoned up by some older American photographers, such as Clarence John Laughlin, a self-avowed exponent of "extreme romanticism" who began in the mid-1930s photographing decaying plantation houses of the lower Mississippi, funerary monuments in Louisiana's swamp burial grounds, Victorian interiors in Milwaukee and Chicago; but the method works as well on subjects which do not, so conventionally, reek of the past, as in a Laughlin photograph from 1962, "Spectre of Coca-Cola." In addition to romanticism (extreme or not) about the past, photography offers instant romanticism about the present. In America, the photographer is not simply the person who records the past but the one who invents it. As Berenice Abbott writes: "The photographer is the contemporary being par excellence; through his eyes the now becomes past."

Returning to New York from Paris in 1929, after the years of apprenticeship with Man Ray and her discovery (and rescue) of the then barely known work of Eugène Atget, Abbott set about recording the city. In the preface to her book of photographs that came out in 1939, *Changing New York*, she explains: "If I had never left America, I would never have

wanted to photograph New York. But when I saw it with fresh eyes, I knew it was *my* country, something I had to set down in photographs." Abbott's purpose ("I wanted to record it before it changed completely") sounds like that of Atget, who spent the years between 1898 and his death in 1927 patiently, furtively documenting a small-scale, time-worn Paris that was vanishing. But Abbott is setting down something even more fantastic: the ceaseless replacement of the new. The New York of the thirties was very different from Paris: "not so much beauty and tradition as native fantasia emerging from accelerated greed." Abbott's book is aptly titled, for she is not so much memorializing the past as simply documenting ten years of the chronic self-destruct quality of American experience, in which even the recent past is constantly being used up, swept away, torn down, thrown out, traded in. Fewer and fewer Americans possess objects that have a patina, old furniture, grandparents' pots and pans—the used things, warm with generations of human touch, that Rilke celebrated in *The Duino Elegies* as being essential to a human landscape. Instead, we have our paper phantoms, transistorized landscapes. A featherweight portable museum.

PHOTOGRAPHS, WHICH TURN THE past into a consumable object, are a short cut. Any collection of photographs is an exercise in Surrealist montage and the Surrealist abbreviation of history. As Kurt Schwitters and, more recently, Bruce Conner and Ed Kienholz have made brilliant objects, tableaux,

environments out of refuse, we now make a history out of our detritus. And some virtue, of a civic kind appropriate to a democratic society, is attached to the practice. The true modernism is not austerity but a garbage-strewn plenitude—the willful travesty of Whitman's magnanimous dream. Influenced by the photographers and the pop artists, architects like Robert Venturi learn from Las Vegas and find Times Square a congenial successor to the Piazza San Marco; and Reyner Banham lauds Los Angeles's "instant architecture and instant townscape" for its gift of freedom, of a good life impossible amid the beauties and squalors of the European city—extolling the liberation offered by a society whose consciousness is built, *ad hoc*, out of scraps and junk. America, that surreal country, is full of found objects. Our junk has become art. Our junk has become history.

Photographs are, of course, artifacts. But their appeal is that they also seem, in a world littered with photographic relics, to have the status of found objects—unpremeditated slices of the world. Thus, they trade simultaneously on the prestige of art and the magic of the real. They are clouds of fantasy and pellets of information. Photography has become the quintessential art of affluent, wasteful, restless societies—an indispensable tool of the new mass culture that took shape here after the Civil War, and conquered Europe only after World War II, although its values had gained a foothold among the well-off as early as the 1850s when, according to the splenetic description of Baudelaire, "our squalid society"

became narcissistically entranced by Daguerre's "cheap method of disseminating a loathing for history."

The Surrealist purchase on history also implies an undertow of melancholy as well as a surface voracity and impertinence. At the very beginning of photography, the late 1830s, William H. Fox Talbot noted the camera's special aptitude for recording "the injuries of time." Fox Talbot was talking about what happens to buildings and monuments. For us, the more interesting abrasions are not of stone but of flesh. Through photographs we follow in the most intimate, troubling way the reality of how people age. To look at an old photograph of oneself, of anyone one has known, or of a much photographed public person is to feel, first of all: how much *younger* I (she, he) was then. Photography is the inventory of mortality. A touch of the finger now suffices to invest a moment with posthumous irony. Photographs show people being so irrefutably *there* and at a specific age in their lives; group together people and things which a moment later have already disbanded, changed, continued along the course of their independent destinies. One's reaction to the photographs Roman Vishniac took in 1938 of daily life in the ghettos of Poland is overwhelmingly affected by the knowledge of how soon all these people were to perish. To the solitary stroller, all the faces in the stereotyped photographs cupped behind glass and affixed to tombstones in the cemeteries of Latin countries seem to contain a portent of their death. Photographs state the innocence, the vulnerability of lives heading toward their own

destruction, and this link between photography and death haunts all photographs of people. Some working-class Berliners in Robert Siodmak's film *Menschen am Sonntag* (1929) are having their pictures taken at the end of a Sunday outing. One by one they step before the itinerant photographer's black box—grin, look anxious, clown, stare. The movie camera lingers in close-up to let us savor the mobility of each face; then we see the face frozen in the last of its expressions, embalmed in a still. The photographs shock, in the flow of the movie—transmuting, in an instant, present into past, life into death. And one of the most disquieting films ever made, Chris Marker's *La Jetée* (1963), is the tale of a man who foresees his own death, narrated entirely with still photographs.

As the fascination that photographs exercise is a reminder of death, it is also an invitation to sentimentality. Photographs turn the past into an object of tender regard, scrambling moral distinctions and disarming historical judgments by the generalized pathos of looking at time past. One recent book arranges in alphabetical order the photographs of an incongruous group of celebrities as babies or children. Stalin and Gertrude Stein, who face outward from opposite pages, look equally solemn and huggable; Elvis Presley and Proust, another pair of youthful page-mates, slightly resemble each other; Hubert Humphrey (age 3) and Aldous Huxley (age 8), side by side, have in common that both already display the forceful exaggerations of character for which they were to be known as adults. No picture in the book is without interest

and charm, given what we know (including, in most cases, photographs) of the famous creatures those children were to become. For this and similar ventures in Surrealist irony, naïve snapshots or the most conventional studio portraits are most effective: such pictures seem even more odd, moving, premonitory.

Rehabilitating old photographs, by finding new contexts for them, has become a major book industry. A photograph is only a fragment, and with the passage of time its moorings come unstuck. It drifts away into a soft abstract pastness, open to any kind of reading (or matching to other photographs). A photograph could also be described as a quotation, which makes a book of photographs like a book of quotations. And an increasingly common way of presenting photographs in book form is to match photographs themselves with quotes.

One example: Bob Adelman's *Down Home* (1972), a portrait of a rural Alabama county, one of the poorest in the nation, taken over a five-year period in the 1960s. Illustrating the continuing predilection of documentary photography for losers, Adelman's book descends from *Let Us Now Praise Famous Men*, whose point was precisely that its subjects were not famous, but forgotten. But Walker Evans's photographs were accompanied by eloquent prose written (sometimes overwritten) by James Agee, which aimed to deepen the reader's empathy with the sharecroppers' lives. No one presumes to speak for Adelman's subjects. (It is characteristic of the liberal

sympathies which inform his book that it purports to have no point of view at all—that is, to be an entirely impartial, non-empathic look at its subjects.) *Down Home* could be considered a version in miniature, county-wide, of August Sander's project: to compile an objective photographic record of a people. But these specimens talk, which lends a weight to these unpretentious photographs that they would not have on their own. Paired with their words, their photographs characterize the citizens of Wilcox County as people obliged to defend or exhibit their territory; suggest that these lives are, in a literal sense, a series of positions or poses.

Another example: Michael Lesy's *Wisconsin Death Trip* (1973), which also constructs, with the aid of photographs, a portrait of a rural county—but the time is the past, between 1890 and 1910, years of severe recession and economic hardship, and Jackson County is reconstructed by means of found objects dating from those decades. These consist of a selection of photographs taken by Charles Van Schaick, the county seat's leading commercial photographer, some three thousand of whose glass negatives are stored in the State Historical Society of Wisconsin; and quotations from period sources, mainly local newspapers and the records of the county insane asylum, and fiction about the Midwest. The quotations have nothing to do with the photographs but are correlated with them in an aleatoric, intuitive way, as words and sounds by John Cage are matched at the time of performance with the dance movements already choreographed by Merce Cunningham.

The people photographed in *Down Home* are the authors of the declarations we read on the facing pages. White and black, poor and well-off talk, exhibiting contrasting views (particularly on matters of class and race). But whereas the statements that go with Adelman's photographs contradict each other, the texts that Lesy has collected all say the same thing: that an astonishing number of people in turn-of-the-century America were bent on hanging themselves in barns, throwing their children into wells, cutting their spouses' throats, taking off their clothes on Main Street, burning their neighbors' crops, and sundry other acts likely to land them in jail or the loony bin. In case anyone was thinking that it was Vietnam and all the domestic funk and nastiness of the past decade which had made America a country of darkening hopes, Lesy argues that the dream had collapsed by the end of the last century—not in the inhuman cities but in the farming communities; that the whole country has been crazy, and for a long time. Of course, *Wisconsin Death Trip* doesn't actually prove anything. The force of its historical argument is the force of collage. To Van Schaick's disturbing, handsomely time-eroded photographs Lesy could have matched other texts from the period—love letters, diaries—to give another, perhaps less desperate impression. His book is rousing, fashionably pessimistic polemic, and totally whimsical as history.

A number of American authors, most notably Sherwood Anderson, have written as polemically about the miseries of small-town life at roughly the time covered by Lesy's book.

But although works of photo-fiction like *Wisconsin Death Trip* explain less than many stories and novels, they persuade more now, because they have the authority of a document. Photographs—and quotations—seem, because they are taken to be pieces of reality, more authentic than extended literary narratives. The only prose that seems credible to more and more readers is not the fine writing of someone like Agee, but the raw record—edited or unedited talk into tape recorders; fragments or the integral texts of sub-literary documents (court records, letters, diaries, psychiatric case histories, etc.); self-deprecatingly sloppy, often paranoid first-person reportage. There is a rancorous suspicion in America of whatever seems literary, not to mention a growing reluctance on the part of young people to read anything, even subtitles in foreign movies and copy on a record sleeve, which partly accounts for the new appetite for books of few words and many photographs. (Of course, photography itself increasingly reflects the prestige of the rough, the self-disparaging, the offhand, the undisciplined—the "anti-photograph.")

"All of the men and women the writer had ever known had become grotesques," Anderson says in the prologue to *Winesburg, Ohio* (1919), the title of which was originally supposed to be *The Book of the Grotesque*. He goes on: "The grotesques were not all horrible. Some were amusing, some almost beautiful . . ." Surrealism is the art of generalizing the grotesque and then discovering nuances (and charms) in *that*. No activity is better equipped to exercise the Surrealist way of looking

than photography, and eventually we look at all photographs surrealistically. People are ransacking their attics and the archives of city and state historical societies for old photographs; ever more obscure or forgotten photographers are being rediscovered. Books of photography pile higher and higher—measuring the lost past (hence, the promotion of amateur photography), taking the temperature of the present. Photographs furnish instant history, instant sociology, instant participation. But there is something remarkably anodyne about these new forms of packaging reality. The Surrealist strategy, which promised a new and exciting vantage point for the radical criticism of modern culture, has devolved into an easy irony that democratizes all evidence, that equates its scatter of evidence with history. Surrealism can only deliver a reactionary judgment; can make out of history only an accumulation of oddities, a joke, a death trip.

THE TASTE FOR QUOTATIONS (and for the juxtaposition of incongruous quotations) is a Surrealist taste. Thus, Walter Benjamin—whose Surrealist sensibility is the most profound of anyone's on record—was a passionate collector of quotations. In her magisterial essay on Benjamin, Hannah Arendt recounts that "nothing was more characteristic of him in the thirties than the little notebooks with black covers which he always carried with him and in which he tirelessly entered in the form of quotations what daily living and reading netted him in the way of 'pearls' and 'coral.' On

occasion he read from them aloud, showed them around like items from a choice and precious collection." Though collecting quotations could be considered as merely an ironic mimetism—victimless collecting, as it were—this should not be taken to mean that Benjamin disapproved of, or did not indulge in, the real thing. For it was Benjamin's conviction that reality itself invited—and vindicated—the once heedless, inevitably destructive ministrations of the collector. In a world that is well on its way to becoming one vast quarry, the collector becomes someone engaged in a pious work of salvage. The course of modern history having already sapped the traditions and shattered the living wholes in which precious objects once found their place, the collector may now in good conscience go about excavating the choicer, more emblematic fragments.

The past itself, as historical change continues to accelerate, has become the most surreal of subjects—making it possible, as Benjamin said, to see a new beauty in what is vanishing. From the start, photographers not only set themselves the task of recording a disappearing world but were so employed by those hastening its disappearance. (As early as 1842, that indefatigable improver of French architectural treasures, Viollet-le-Duc, commissioned a series of daguerreotypes of Notre Dame before beginning his restoration of the cathedral.) "To renew the old world," Benjamin wrote, "that is the collector's deepest desire when he is driven to acquire new things." But the old world cannot be renewed—certainly not

by quotations; and this is the rueful, quixotic aspect of the photographic enterprise.

Benjamin's ideas are worth mentioning because he was photography's most original and important critic—despite (and because of) the inner contradiction in his account of photography which follows from the challenge posed by his Surrealist sensibility to his Marxist/Brechtian principles—and because Benjamin's own ideal project reads like a sublimated version of the photographer's activity. This project was a work of literary criticism that was to consist entirely of quotations, and would thereby be devoid of anything that might betray empathy. A disavowal of empathy, a disdain for message-mongering, a claim to be invisible—these are strategies endorsed by most professional photographers. The history of photography discloses a long tradition of ambivalence about its capacity for partisanship: the taking of sides is felt to undermine its perennial assumption that all subjects have validity and interest. But what in Benjamin is an excruciating idea of fastidiousness, meant to permit the mute past to speak in its own voice, with all its unresolvable complexity, becomes—when generalized, in photography—the cumulative de-creation of the past (in the very act of preserving it), the fabrication of a new, parallel reality that makes the past immediate while underscoring its comic or tragic ineffectuality, that invests the specificity of the past with an unlimited irony, that transforms the present into the past and the past into pastness.

Like the collector, the photographer is animated by a passion that, even when it appears to be for the present, is linked to a sense of the past. But while traditional arts of historical consciousness attempt to put the past in order, distinguishing the innovative from the retrograde, the central from the marginal, the relevant from the irrelevant or merely interesting, the photographer's approach—like that of the collector—is unsystematic, indeed anti-systematic. The photographer's ardor for a subject has no essential relation to its content or value, that which makes a subject classifiable. It is, above all, an affirmation of the subject's thereness; its rightness (the rightness of a look on a face, of the arrangement of a group of objects), which is the equivalent of the collector's standard of genuineness; its quiddity—whatever qualities make it unique. The professional photographer's preeminently willful, avid gaze is one that not only resists the traditional classification and evaluation of subjects but seeks consciously to defy and subvert them. For this reason, its approach to subject matter is a good deal less aleatoric than is generally claimed.

In principle, photography executes the Surrealist mandate to adopt an uncompromisingly egalitarian attitude toward subject matter. (Everything is "real.") In fact, it has—like mainstream Surrealist taste itself—evinced an inveterate fondness for trash, eyesores, rejects, peeling surfaces, odd stuff, kitsch. Thus, Atget specialized in the marginal beauties of jerry-built wheeled vehicles, gaudy or fantastic window displays, the raffish art of shop signs and carousels, ornate

porticoes, curious door knockers and wrought-iron grilles, stucco ornaments on the façades of run-down houses. The photographer—and the consumer of photographs—follows in the footsteps of the ragpicker, who was one of Baudelaire's favorite figures for the modern poet:

Everything that the big city threw away, everything it lost, everything it despised, everything it crushed underfoot, he catalogues and collects . . . He sorts things out and makes a wise choice; he collects, like a miser guarding a treasure, the refuse which will assume the shape of useful or gratifying objects between the jaws of the goddess of Industry.

Bleak factory buildings and billboard-cluttered avenues look as beautiful, through the camera's eye, as churches and pastoral landscapes. More beautiful, by modern taste. Recall that it was Breton and other Surrealists who invented the second-hand store as a temple of vanguard taste and upgraded visits to flea markets into a mode of aesthetic pilgrimage. The Surrealist ragpicker's acuity was directed to finding beautiful what other people found ugly or without interest and relevance—bric-a-brac, naïve or pop objects, urban debris.

As the structuring of a prose fiction, a painting, a film by means of quotations—think of Borges, of Kitaj, of Godard—is a specialized example of Surrealist taste, so the increasingly common practice of putting up photographs on living-room and bedroom walls, where formerly hung reproductions of

paintings, is an index of the wide diffusion of Surrealist taste. For photographs themselves satisfy many of the criteria for Surrealist approbation, being ubiquitous, cheap, unprepossessing objects. A painting is commissioned or bought; a photograph is found (in albums and drawers), cut out (of newspapers and magazines), or easily taken oneself. And the objects that are photographs not only proliferate in a way that paintings don't but are, in a certain sense, aesthetically indestructible. Leonardo's "The Last Supper" in Milan hardly looks better now; it looks terrible. Photographs, when they get scrofulous, tarnished, stained, cracked, faded still look good; do often look better. (In this, as in other ways, the art that photography does resemble is architecture, whose works are subject to the same inexorable promotion through the passage of time; many buildings, and not only the Parthenon, probably look better as ruins.)

What is true of photographs is true of the world seen photographically. Photography extends the eighteenth-century literati's discovery of the beauty of ruins into a genuinely popular taste. And it extends that beauty beyond the romantics' ruins, such as those glamorous forms of decrepitude photographed by Laughlin, to the modernists' ruins—reality itself. The photographer is willy-nilly engaged in the enterprise of antiquing reality, and photographs are themselves instant antiques. The photograph offers a modern counterpart of that characteristically romantic architectural genre, the artificial ruin: the ruin which is created in order to deepen

the historical character of a landscape, to make nature suggestive—suggestive of the past.

The contingency of photographs confirms that everything is perishable; the arbitrariness of photographic evidence indicates that reality is fundamentally unclassifiable. Reality is summed up in an array of casual fragments—an endlessly alluring, poignantly reductive way of dealing with the world. Illustrating that partly jubilant, partly condescending relation to reality that is the rallying point of Surrealism, the photographer's insistence that everything is real also implies that the real is not enough. By proclaiming a fundamental discontent with reality, Surrealism bespeaks a posture of alienation which has now become a general attitude in those parts of the world which are politically powerful, industrialized, and camera-wielding. Why else would reality ever be thought of as insufficient, flat, overordered, shallowly rational? In the past, a discontent with reality expressed itself as a longing for *another* world. In modern society, a discontent with reality expresses itself forcefully and most hauntingly by the longing to reproduce *this* one. As if only by looking at reality in the form of an object—through the fix of the photograph—is it really real, that is, surreal.

Photography inevitably entails a certain patronizing of reality. From being "out there," the world comes to be "inside" photographs. Our heads are becoming like those magic boxes that Joseph Cornell filled with incongruous small objects whose provenance was a France he never once visited. Or like

a hoard of old movie stills, of which Cornell amassed a vast collection in the same Surrealist spirit: as nostalgia-provoking relics of the original movie experience, as means of a token possession of the beauty of actors. But the relation of a still photograph to a film is intrinsically misleading. To quote from a movie is not the same as quoting from a book. Whereas the reading time of a book is up to the reader, the viewing time of a film is set by the filmmaker and the images are perceived only as fast or as slowly as the editing permits. Thus, a still, which allows one to linger over a single moment as long as one likes, contradicts the very form of film, as a set of photographs that freezes moments in a life or a society contradicts their form, which is a process, a flow in time. The photographed world stands in the same, essentially inaccurate relation to the real world as stills do to movies. Life is not about significant details, illuminated a flash, fixed forever. Photographs are.

The lure of photographs, their hold on us, is that they offer at one and the same time a connoisseur's relation *to* the world and a promiscuous acceptance *of* the world. For this connoisseur's relation to the world is, through the evolution of the modernist revolt against traditional aesthetic norms, deeply implicated in the promotion of kitsch standards of taste. Though some photographs, considered as individual objects, have the bite and sweet gravity of important works of art, the proliferation of photographs is ultimately an affirmation of kitsch. Photography's ultra-mobile gaze flatters the viewer,

creating a false sense of ubiquity, a deceptive mastery of experience. Surrealists, who aspire to be cultural radicals, even revolutionaries, have often been under the well-intentioned illusion that they could be, indeed should be, Marxists. But Surrealist aestheticism is too suffused with irony to be compatible with the twentieth century's most seductive form of moralism. Marx reproached philosophy for only trying to understand the world rather than trying to change it. Photographers, operating within the terms of the Surrealist sensibility, suggest the vanity of even trying to understand the world and instead propose that we collect it.

The Heroism of Vision

Nobody ever discovered ugliness through photographs. But many, through photographs, have discovered beauty. Except for those situations in which the camera is used to document, or to mark social rites, what moves people to take photographs is finding something beautiful. (The name under which Fox Talbot patented the photograph in 1841 was the calotype: from *kalos*, beautiful.) Nobody exclaims, "Isn't that ugly! I must take a photograph of it." Even if someone did say that, all it would mean is: "I find that ugly thing . . . beautiful."

It is common for those who have glimpsed something beautiful to express regret at not having been able to photograph it. So successful has been the camera's role in beautifying the world that photographs, rather than the world, have become the standard of the beautiful. House-proud hosts may well pull out photographs of the place to show visitors how really splendid it is. We learn to see ourselves photographically: to regard oneself as attractive is, precisely, to judge that one would look good in a photograph. Photographs create the beautiful and—over generations of picture-taking—use it up. Certain glories of nature, for

example, have been all but abandoned to the indefatigable attentions of amateur camera buffs. The image-surfeited are likely to find sunsets corny; they now look, alas, too much like photographs.

Many people are anxious when they're about to be photographed: not because they fear, as primitives do, being violated but because they fear the camera's disapproval. People want the idealized image: a photograph of themselves looking their best. They feel rebuked when the camera doesn't return an image of themselves as more attractive than they really are. But few are lucky enough to be "photogenic"—that is, to look better in photographs (even when not made up or flattered by the lighting) than in real life. That photographs are often praised for their candor, their honesty, indicates that most photographs, of course, are *not* candid. A decade after Fox Talbot's negative-positive process had begun replacing the daguerreotype (the first practicable photographic process) in the mid-1840s, a German photographer invented the first technique for retouching the negative. His two versions of the same portrait—one retouched, the other not—astounded crowds at the Exposition Universelle held in Paris in 1855 (the second world fair, and the first with a photography exhibit). The news that the camera could lie made getting photographed much more popular.

The consequences of lying have to be more central for photography than they ever can be for painting, because the flat, usually rectangular images which are photographs make a

claim to be true that paintings can never make. A fake painting (one whose attribution is false) falsifies the history of art. A fake photograph (one which has been retouched or tampered with, or whose caption is false) falsifies reality. The history of photography could be recapitulated as the struggle between two different imperatives: beautification, which comes from the fine arts, and truth-telling, which is measured not only by a notion of value-free truth, a legacy from the sciences, but by a moralized ideal of truth-telling, adapted from nineteenth-century literary models and from the (then) new profession of independent journalism. Like the post-romantic novelist and the reporter, the photographer was supposed to unmask hypocrisy and combat ignorance. This was a task which painting was too slow and cumbersome a procedure to take on, no matter how many nineteenth-century painters shared Millet's belief that *le beau c'est le vrai*. Astute observers noticed that there was something naked about the truth a photograph conveyed, even when its maker did not mean to pry. In *The House of the Seven Gables* (1851) Hawthorne has the young photographer, Holgrave, remark about the daguerreotype portrait that "while we give it credit only for depicting the merest surface, it actually brings out the secret character with a truth that no painter would ever venture upon, even could he detect it."

Freed from the necessity of having to make narrow choices (as painters did) about what images were worth contemplating, because of the rapidity with which cameras recorded

anything, photographers made seeing into a new kind of project: as if seeing itself, pursued with sufficient avidity and single-mindedness, could indeed reconcile the claims of truth and the need to find the world beautiful. Once an object of wonder because of its capacity to render reality faithfully as well as despised at first for its base accuracy, the camera has ended by effecting a tremendous promotion of the value of appearances. Appearances as the camera records them. Photographs do not simply render reality—realistically. It is reality which is scrutinized, and evaluated, for its fidelity to photographs. "In my view," the foremost ideologue of literary realism, Zola, declared in 1901 after fifteen years of amateur picture-taking, "you cannot claim to have really seen something until you have photographed it." Instead of just recording reality, photographs have become the norm for the way things appear to us, thereby changing the very idea of reality, and of realism.

THE EARLIEST PHOTOGRAPHERS TALKED as if the camera were a copying machine; as if, while people operate cameras, it is the camera that sees. The invention of photography was welcomed as a means of easing the burden of ever accumulating information and sense impressions. In his book of photographs *The Pencil of Nature* (1844–46) Fox Talbot relates that the idea of photography came to him in 1833, on the Italian Journey that had become obligatory for Englishmen of inherited wealth like himself, while making some sketches of

the landscape at Lake Como. Drawing with the help of a camera obscura, a device which projected the image but did not fix it, he was led to reflect, he says, "on the inimitable beauty of the pictures of nature's painting which the glass lens of the camera throws upon the paper" and to wonder "if it were possible to cause these natural images to imprint themselves durably." The camera suggested itself to Fox Talbot as a new form of notation whose allure was precisely that it was impersonal—because it recorded a "natural" image; that is, an image which comes into being "by the agency of Light alone, without any aid whatever from the artist's pencil."

The photographer was thought to be an acute but non-interfering observer—a scribe, not a poet. But as people quickly discovered that nobody takes the same picture of the same thing, the supposition that cameras furnish an impersonal, objective image yielded to the fact that photographs are evidence not only of what's there but of what an individual sees, not just a record but an evaluation of the world.*

*The restriction of photography to impersonal seeing has of course continued to have its advocates. Among the Surrealists, photography was thought to be liberating to the extent that it transcended mere personal expression: Breton starts his essay of 1920 on Max Ernst by calling the practice of automatic writing "a true photography of thought," the camera being regarded as "a blind instrument" whose superiority in "the imitation of appearances" had "dealt a mortal blow to the old modes of expression, in painting as well as poetry." In the opposing aesthetic camp, the Bauhaus theoreticians took a not dissimilar view, treating photography as a branch

It became clear that there was not just a simple, unitary activity called seeing (recorded by, aided by cameras) but "photographic seeing," which was both a new way for people to see and a new activity for them to perform.

A Frenchman with a daguerreotype camera was already roaming the Pacific in 1841, the same year that the first volume of *Excursions daguerriennes: Vues et monuments les plus remarquables du globe* was published in Paris. The 1850s was the great age of photographic Orientalism: Maxime Du Camp, making a Grand Tour of the Middle East with Flaubert between 1849 and 1851, centered his picture-taking activity on attractions like the Colossus of Abu Simbel and the Temple of Baalbek, not the daily life of fellahin. Soon, however, travelers with cameras annexed a wider subject matter than famous sites and works of art. Photographic seeing meant an aptitude for discovering beauty in what everybody sees but neglects as too ordinary. Photographers were supposed to do more than just see the world as it is, including its already acclaimed marvels; they were to create interest, by new visual decisions.

There is a peculiar heroism abroad in the world since the invention of cameras: the heroism of vision. Photography

of design, like architecture—creative but impersonal, unencumbered by such vanities as the painterly surface, the personal touch. In his book *Painting, Photography, Film* (1925) Moholy-Nagy praises the camera for imposing "the hygiene of the optical," which will eventually "abolish that pictorial and imaginative association pattern . . . which has been stamped upon our vision by great individual painters."

opened up a new model of freelance activity—allowing each person to display a certain unique, avid sensibility. Photographers departed on their cultural and class and scientific safaris, searching for striking images. They would entrap the world, whatever the cost in patience and discomfort, by this active, acquisitive, evaluating, gratuitous modality of vision. Alfred Stieglitz proudly reports that he had stood three hours during a blizzard on February 22, 1893, "awaiting the proper moment" to take his celebrated picture, "Fifth Avenue, Winter." The proper moment is when one can see things (especially what everyone has already seen) in a fresh way. The quest became the photographer's trademark in the popular imagination. By the 1920s the photographer had become a modern hero, like the aviator and the anthropologist—without necessarily having to leave home. Readers of the popular press were invited to join "our photographer" on a "journey of discovery," visiting such new realms as "the world from above," "the world under the magnifying glass," "the beauties of every day," "the unseen universe," "the miracle of light," "the beauty of machines," the picture that can be "found in the street."

Everyday life apotheosized, and the kind of beauty that only the camera reveals—a corner of material reality that the eye doesn't see at all or can't normally isolate; or the overview, as from a plane—these are the main targets of the photographer's conquest. For a while the close-up seemed to be photography's most original method of seeing.

Photographers found that as they more narrowly cropped reality, magnificent forms appeared. In the early 1840s the versatile, ingenious Fox Talbot not only composed photographs in the genres taken over from painting—portrait, domestic scene, townscape, landscape, still life—but also trained his camera on a seashell, on the wings of a butterfly (enlarged with the aid of a solar microscope), on a portion of two rows of books in his study. But his subjects are still recognizably a shell, butterfly wings, books. When ordinary seeing was further violated—and the object isolated from its surroundings, rendering it abstract—new conventions about what was beautiful took hold. What is beautiful became just what the eye can't (or doesn't) see: that fracturing, dislocating vision that only the camera supplies.

In 1915 Paul Strand took a photograph which he titled "Abstract Patterns Made by Bowls." In 1917 Strand turned to close-ups of machine forms, and throughout the twenties did close-up nature studies. The new procedure—its heyday was between 1920 and 1935—seemed to promise unlimited visual delights. It worked with equally stunning effect on homely objects, on the nude (a subject one might have supposed to be virtually exhausted by painters), on the tiny cosmologies of nature. Photography seemed to have found its grandiose role, as the bridge between art and science; and painters were admonished to learn from the beauties of microphotographs and aerial views in Moholy-Nagy's book *Von Material zur Architektur*, published by the Bauhaus in 1928 and translated

into English as *The New Vision*. It was the same year as the appearance of one of the first photographic best-sellers, a book by Albert Renger-Patzsch entitled *Die Welt ist schön (The World Is Beautiful)*, which consisted of one hundred photographs, mostly close-ups, whose subjects range from a colocasia leaf to a potter's hands. Painting never made so shameless a promise to prove the world beautiful.

The abstracting eye—represented with particular brilliance in the period between the two world wars by some of the work of Strand, as well as of Edward Weston and Minor White—seems to have been possible only after the discoveries made by modernist painters and sculptors. Strand and Weston, who both acknowledge a similarity between their ways of seeing and those of Kandinsky and Brancusi, may have been attracted to the hard edge of Cubist style in reaction to the softness of Stieglitz's images. But it is just as true that the influence flowed the other way. In 1909, in his magazine *Camera Work*, Stieglitz notes the undeniable influence of photography on painting, although he cites only the Impressionists—whose style of "blurred definition" inspired his own.* And Moholy-Nagy in *The New Vision*

*The large influence that photography exercised upon the Impressionists is a commonplace of art history. Indeed, it is not much of an exaggeration to say, as Stieglitz does, that "the impressionist painters adhere to a style of composition that is strictly photographic." The camera's translation of reality into highly polarized areas of light and dark, the free or arbitrary cropping of the image in photographs, the indifference of photographers

correctly points out that "the technique and spirit of photography directly or indirectly influenced Cubism." But for all the ways in which, from the 1840s on, painters and photographers have mutually influenced and pillaged each other, their procedures are fundamentally opposed. The painter constructs, the photographer discloses. That is, the identification of the subject of a photograph always dominates our perception of it—as it does not, necessarily, in a painting. The subject of Weston's "Cabbage Leaf," taken in 1931, looks like a fall of gathered cloth; a title is needed to identify it. Thus, the image makes its point in two ways. The form is pleasing, and it is (surprise!) the form of a cabbage leaf. If it were gathered cloth, it wouldn't be so beautiful. We already know that beauty, from the fine arts. Hence the formal qualities of style—the central issue in painting—are, at most, of secondary importance in photography, while what a photograph is *of* is always of primary importance. The assumption underlying all uses of photography, that each photograph is a piece of the world, means that we don't know how to react to a photograph (if

to making space, particularly background space, intelligible—these were the main inspiration for the Impressionist painters' professions of scientific interest in the properties of light, for their experiments in flattened perspective and unfamiliar angles and decentralized forms that are sliced off by the picture's edge. ("They depict life in scraps and fragments," as Stieglitz observed in 1909.) A historical detail: the very first Impressionist exhibition, in April 1874, was held in Nadar's photography studio on the Boulevard des Capucines in Paris.

the image is visually ambiguous: say, too closely seen or too distant) until we know *what* piece of the world it is. What looks like a bare coronet—the famous photograph taken by Harold Edgerton in 1936—becomes far more interesting when we find out it is a splash of milk.

Photography is commonly regarded as an instrument for knowing things. When Thoreau said, "You can't say more than you see," he took for granted that sight had pride of place among the senses. But when, several generations later, Thoreau's dictum is quoted by Paul Strand to praise photography, it resonates with a different meaning. Cameras did not simply make it possible to apprehend more by seeing (through micro-photography and teledetection). They changed seeing itself, by fostering the idea of seeing for seeing's sake. Thoreau still lived in a polysensual world, though one in which observation had already begun to acquire the stature of a moral duty. He was talking about a seeing not cut off from the other senses, and about seeing in context (the context he called Nature), that is, a seeing linked to certain presuppositions about what he thought was worth seeing. When Strand quotes Thoreau, he assumes another attitude toward the sensorium: the didactic cultivation of perception, independent of notions about what is worth perceiving, which animates all modernist movements in the arts.

The most influential version of this attitude is to be found in painting, the art which photography encroached on re-morselessly and plagiarized from enthusiastically from its

beginnings, and with which it still coexists in febrile rivalry. According to the usual account, what photography did was to usurp the painter's task of providing images that accurately transcribe reality. For this "the painter should be deeply grateful," insists Weston, viewing this usurpation, as have many photographers before and since, as in fact a liberation. By taking over the task of realistic picturing hitherto monopolized by painting, photography freed painting for its great modernist vocation—abstraction. But photography's impact on painting was not as clear-cut as that. For, as photography was entering the scene, painting was already, on its own, beginning its long retreat from realistic representation— Turner was born in 1775, Fox Talbot in 1800—and the territory photography came to occupy with such rapid and complete success would probably have been depopulated anyway. (The instability of nineteenth-century painting's strictly representational achievements is most clearly demonstrated by the fate of portraiture, which came more and more to be about painting itself rather than about sitters—and eventually ceased to interest most ambitious painters, with such notable recent exceptions as Francis Bacon and Warhol, who borrow lavishly from photographic imagery.)

The other important aspect of the relation between painting and photography omitted in the standard account is that the frontiers of the new territory acquired by photography immediately started expanding, as some photographers refused to be confined to turning out those ultra-realistic

triumphs with which painters could not compete. Thus, of the two famous inventors of photography, Daguerre never conceived of going beyond the naturalist painter's range of representation, while Fox Talbot immediately grasped the camera's ability to isolate forms which normally escape the naked eye and which painting had never recorded. Gradually photographers joined in the pursuit of more abstract images, professing scruples reminiscent of the modernist painters' dismissal of the mimetic as mere picturing. Painting's revenge, if you will. The claim made by many professional photographers to do something quite different from recording reality is the clearest index of the immense counter-influence that painting has had on photography. But however much photographers have come to share some of the same attitudes about the inherent value of perception exercised for perception's sake and the (relative) unimportance of subject matter which have dominated advanced painting for more than a century, their applications of these attitudes cannot duplicate those of painting. For it is in the nature of a photograph that it can never entirely transcend its subject, as a painting can. Nor can a photograph ever transcend the visual itself, which is in some sense the ultimate aim of modernist painting.

The version of the modernist attitude most relevant to photography is not to be found in painting—even as it was then (at the time of its conquest, or liberation, by photography), certainly as it is now. Except for such marginal phenomena as Super Realism, a revival of Photo-Realism which is not

content with merely imitating photographs but aims to show that painting can achieve an even greater illusion of verisimilitude, painting is still largely ruled by a suspicion of what Duchamp called the merely retinal. The ethos of photography—that of schooling us (in Moholy-Nagy's phrase) in "intensive seeing"—seems closer to that of modernist poetry than that of painting. As painting has become more and more conceptual, poetry (since Apollinaire, Eliot, Pound, and William Carlos Williams) has more and more defined itself as concerned with the visual. ("No truth but in things," as Williams declared.) Poetry's commitment to concreteness and to the autonomy of the poem's language parallels photography's commitment to pure seeing. Both imply discontinuity, disarticulated forms and compensatory unity: wrenching things from their context (to see them in a fresh way), bringing things together elliptically, according to the imperious but often arbitrary demands of subjectivity.

WHILE MOST PEOPLE TAKING photographs are only seconding received notions of the beautiful, ambitious professionals usually think they are challenging them. According to heroic modernists like Weston, the photographer's venture is elitist, prophetic, subversive, revelatory. Photographers claimed to be performing the Blakean task of cleansing the senses, "revealing to others the living world around them," as Weston described his own work, "showing to them what their own unseeing eyes had missed."

Although Weston (like Strand) also claimed to be indifferent to the question of whether photography is an art, his demands on photography still contained all the romantic assumptions about the photographer as Artist. By the century's second decade, certain photographers had confidently appropriated the rhetoric of a vanguard art: armed with cameras, they were doing rude battle with conformist sensibilities, busy fulfilling Pound's summons to Make It New. Photography, not "soft, gutless painting," says Weston with virile disdain, is best equipped to "bore into the spirit of today." Between 1930 and 1932 Weston's diaries or *Daybooks* are full of effusive premonitions of impending change and declarations of the importance of the visual shock therapy that photographers were administering. "Old ideals are crashing on all sides, and the precise uncompromising camera vision is, and will be more so, a world force in the revaluation of life."

Weston's notion of the photographer's agon shares many themes with the heroic vitalism of the 1920s popularized by D. H. Lawrence: affirmation of the sensual life, rage at bourgeois sexual hypocrisy, self-righteous defense of egotism in the service of one's spiritual vocation, manly appeals for a union with nature. (Weston calls photography "a way of self-development, a means to discover and identify oneself with all the manifestations of basic forms—with nature, the source.") But while Lawrence wanted to restore the wholeness of sensory appreciation, the photographer—even

one whose passions seem so reminiscent of Lawrence's—necessarily insists on the preeminence of one sense: sight. And, contrary to what Weston asserts, the habit of photographic seeing—of looking at reality as an array of potential photographs—creates estrangement from, rather than union with, nature.

Photographic seeing, when one examines its claims, turns out to be mainly the practice of a kind of dissociative seeing, a subjective habit which is reinforced by the objective discrepancies between the way that the camera and the human eye focus and judge perspective. These discrepancies were much remarked by the public in the early days of picture-taking. Once they began to think photographically, people stopped talking about photographic distortion, as it was called. (Now, as William Ivins, Jr., has pointed out, they actually hunt for that distortion.) Thus, one of the perennial successes of photography has been its strategy of turning living beings into things, things into living beings. The peppers Weston photographed in 1929 and 1930 are voluptuous in a way that his female nudes rarely are. Both the nudes and the pepper are photographed for the play of forms—but the body is characteristically shown bent over upon itself, all the extremities cropped, with the flesh rendered as opaque as normal lighting and focus allow, thus decreasing its sensuality and heightening the abstractness of the body's form; the pepper is viewed close-up but in its entirety, the skin polished or oiled, and the result is a discovery of the erotic suggestiveness

of an ostensibly neutral form, a heightening of its seeming palpability.

It was the beauty of forms in industrial and scientific photography that dazzled the Bauhaus designers, and, indeed, the camera has recorded few images more interesting formally than those taken by metallurgists and crystallographers. But the Bauhaus approach to photography has not prevailed. No one now considers the beauty revealed in photographs to be epitomized by scientific microphotography. In the main tradition of the beautiful in photography, beauty requires the imprint of a human decision: that *this* would make a good photograph, and that the good picture would make some comment. It proved more important to reveal the elegant form of a toilet bowl, the subject of a series of pictures Weston did in Mexico in 1925, than the poetic magnitude of a snowflake or a coal fossil.

For Weston, beauty itself was subversive—as seemed confirmed when some people were scandalized by his ambitious nudes. (In fact, it was Weston—followed by André Kertész and Bill Brandt—who made nude photography respectable.) Now photographers are more likely to emphasize the ordinary humanity of their revelations. Though photographers have not ceased to look for beauty, photography is no longer thought to create, under the aegis of beauty, a psychic breakthrough. Ambitious modernists, like Weston and Cartier-Bresson, who understand photography as a genuinely new way of seeing (precise, intelligent, even scientific), have been challenged by

photographers of a later generation, like Robert Frank, who want a camera eye that is not piercing but democratic, who don't claim to be setting new standards for seeing. Weston's assertion that "photography has opened the blinds to a new world vision" seems typical of the overoxygenated hopes of modernism in all the arts during the first third of the century— hopes since abandoned. Although the camera did make a psychic revolution, it was hardly in the positive, romantic sense that Weston envisaged.

Insofar as photography does peel away the dry wrappers of habitual seeing, it creates another habit of seeing: both intense and cool, solicitous and detached; charmed by the insignificant detail, addicted to incongruity. But photographic seeing has to be constantly renewed with new shocks, whether of subject matter or technique, so as to produce the impression of violating ordinary vision. For, challenged by the revelations of photographers, seeing tends to accommodate to photographs. The avant-garde vision of Strand in the twenties, of Weston in the late twenties and early thirties, was quickly assimilated. Their rigorous close-up studies of plants, shells, leaves, time-withered trees, kelp, driftwood, eroded rocks, pelicans' wings, gnarled cypress roots, and gnarled workers' hands have become clichés of a merely photographic way of seeing. What it once took a very intelligent eye to see, anyone can see now. Instructed by photographs, everyone is able to visualize that once purely literary conceit, the geography of the body: for example, photographing a pregnant

woman so that her body looks like a hillock, a hillock so that it looks like the body of a pregnant woman.

Increased familiarity does not entirely explain why certain conventions of beauty get used up while others remain. The attrition is moral as well as perceptual. Strand and Weston could hardly have imagined how these notions of beauty could become so banal, yet it seems inevitable once one insists—as Weston did—on so bland an ideal of beauty as perfection. Whereas the painter, according to Weston, has always "tried to improve nature by self-imposition," the photographer has "proved that nature offers an endless number of perfect 'compositions,'—order everywhere." Behind the modernist's belligerent stance of aesthetic purism lay an astonishingly generous acceptance of the world. For Weston, who spent most of his photographic life on the California coast near Carmel, the Walden of the 1920s, it was relatively easy to find beauty and order, while for Aaron Siskind, a photographer of the generation after Strand and a New Yorker, who began his career by taking architectural photographs and genre photographs of city people, the question is one of creating order. "When I make a photograph," Siskind writes, "I want it to be an altogether new object, complete and self-contained, whose basic condition is order." For Cartier-Bresson, to take photographs is "to find the structure of the world—to revel in the pure pleasure of form," to disclose that "in all this chaos, there is order." (It may well be impossible to talk about the perfection of the

world without sounding unctuous.) But displaying the perfection of the world was too sentimental, too ahistorical a notion of beauty to sustain photography. It seems inevitable that Weston, more committed than Strand ever was to abstraction, to the discovery of forms, produced a much narrower body of work than Strand did. Thus Weston never felt moved to do socially conscious photography and, except for the period between 1923 and 1927 that he spent in Mexico, shunned cities. Strand, like Cartier-Bresson, was attracted to the picturesque desolations and damages of urban life. But even far from nature, both Strand and Cartier-Bresson (one could also cite Walker Evans) still photograph with the same fastidious eye that discerns order everywhere.

The view of Stieglitz and Strand and Weston—that photographs should be, first of all, beautiful (that is, beautifully composed)—seems thin now, too obtuse to the truth of disorder: even as the optimism about science and technology which lay behind the Bauhaus view of photography seems almost pernicious. Weston's images, however admirable, however beautiful, have become less interesting to many people, while those taken by the mid-nineteenth-century English and French primitive photographers and by Atget, for example, enthrall more than ever. The judgment of Atget as "not a fine technician" that Weston entered in his *Daybooks* perfectly reflects the coherence of Weston's view and his distance from contemporary taste. "Halation destroyed much, and the color

correction not good," Weston notes; "his instinct for subject matter was keen, but his recording weak,—his construction inexcusable . . . so often one feels he missed the real thing." Contemporary taste faults Weston, with his devotion to the perfect print, rather than Atget and the other masters of photography's demotic tradition. Imperfect technique has come to be appreciated precisely because it breaks the sedate equation of Nature and Beauty. Nature has become more a subject for nostalgia and indignation than an object of contemplation, as marked by the distance of taste which separates both the majestic landscapes of Ansel Adams (Weston's best-known disciple) and the last important body of photographs in the Bauhaus tradition, Andreas Feininger's *The Anatomy of Nature* (1965), from current photographic imagery of nature defiled.

As these formalist ideals of beauty seem, in retrospect, linked to a certain historical mood, optimism about the modern age (the new vision, the new era), so the decline of the standards of photographic purity represented by both Weston and the Bauhaus school has accompanied the moral letdown experienced in recent decades. In the present historical mood of disenchantment one can make less and less sense out of the formalist's notion of timeless beauty. Darker, time-bound models of beauty have become prominent, inspiring a re-evaluation of the photography of the past; and, in an apparent revulsion against the Beautiful, recent generations of photographers prefer to show disorder, prefer to distill an anecdote,

more often than not a disturbing one, rather than isolate an ultimately reassuring "simplified form" (Weston's phrase). But notwithstanding the declared aims of indiscreet, unposed, often harsh photography to reveal truth, not beauty, photography still beautifies. Indeed, the most enduring triumph of photography has been its aptitude for discovering beauty in the humble, the inane, the decrepit. At the very least, the real has a pathos. And that pathos is—beauty. (The beauty of the poor, for example.)

Weston's celebrated photograph of one of his fiercely loved sons, "Torso of Neil," 1925, seems beautiful because of the shapeliness of its subject and because of its bold composition and subtle lighting—a beauty that is the result of skill and taste. Jacob Riis's crude flashlit photographs taken between 1887 and 1890 seem beautiful because of the force of their subject, grimy shapeless New York slum-dwellers of indeterminate age, and because of the rightness of their "wrong" framing and the blunt contrasts produced by the lack of control over tonal values—a beauty that is the result of amateurism or inadvertence. The evaluation of photographs is always shot through with such aesthetic double standards. Initially judged by the norms of painting, which assume conscious design and the elimination of non-essentials, the distinctive achievements of photographic seeing were until quite recently thought to be identical with the work of that relatively small number of photographers who, through reflection and effort, managed to transcend the camera's

mechanical nature to meet the standards of art. But it is now clear that there is no inherent conflict between the mechanical or naïve use of the camera and formal beauty of a very high order, no kind of photograph in which such beauty could not turn out to be present: an unassuming functional snapshot may be as visually interesting, as eloquent, as beautiful as the most acclaimed fine-art photographs. This democratizing of formal standards is the logical counterpart to photography's democratizing of the notion of beauty. Traditionally associated with exemplary models (the representative art of the classical Greeks showed only youth, the body in its perfection), beauty has been revealed by photographs as existing everywhere. Along with people who pretty themselves for the camera, the unattractive and the disaffected have been assigned their beauty.

For photographers there is, finally, no difference—no greater aesthetic advantage—between the effort to embellish the world and the counter-effort to rip off its mask. Even those photographers who disdained retouching their portraits—a mark of honor for ambitious portrait photographers from Nadar on—tended to protect the sitter in certain ways from the camera's too revealing gaze. And one of the typical endeavors of portrait photographers, professionally protective toward famous faces (like Garbo's) which really are ideal, is the search for "real" faces, generally sought among the anonymous, the poor, the socially defenseless, the aged, the insane—people indifferent to (or powerless to protest)

the camera's aggressions. Two portraits that Strand did in 1916 of urban casualties, "Blind Woman" and "Man," are among the first results of this search conducted in close-up. In the worst years of the German depression Helmar Lerski made a whole compendium of distressing faces, published under the title *Köpfe des Alltags (Everyday Faces)* in 1931. The paid models for what Lerski called his "objective character studies"—with their rude revelations of over-enlarged pores, wrinkles, skin blemishes—were out-of-work servants procured from an employment exchange, beggars, street sweepers, vendors, and washerwomen.

The camera can be lenient; it is also expert at being cruel. But its cruelty only produces another kind of beauty, according to the surrealist preferences which rule photographic taste. Thus, while fashion photography is based on the fact that something can be more beautiful in a photograph than in real life, it is not surprising that some photographers who serve fashion are also drawn to the non-photogenic. There is a perfect complementarity between Avedon's fashion photography, which flatters, and the work in which he comes on as The One Who Refuses to Flatter—for example, the elegant, ruthless portraits Avedon did in 1972 of his dying father. The traditional function of portrait painting, to embellish or idealize the subject, remains the aim of everyday and of commercial photography, but it has had a much more limited career in photography considered as an art. Generally speaking, the honors have gone to the Cordelias.

As the vehicle of a certain reaction against the convention-
ally beautiful, photography has served to enlarge vastly our
notion of what is aesthetically pleasing. Sometimes this reac-
tion is in the name of truth. Sometimes it is in the name of
sophistication or of prettier lies: thus, fashion photography
has been developing, over more than a decade, a repertoire of
paroxysmic gestures that shows the unmistakable influence
of Surrealism. ("Beauty will be *convulsive*," Breton wrote, "or
it will not be at all.") Even the most compassionate photojour-
nalism is under pressure to satisfy simultaneously two sorts
of expectations, those arising from our largely surrealist way
of looking at all photographs, and those created by our belief
that some photographs give real and important information
about the world. The photographs that W. Eugene Smith took
in the late 1960s in the Japanese fishing village of Minamata,
most of whose inhabitants are crippled and slowly dying of
mercury poisoning, move us because they document a suffer-
ing which arouses our indignation—and distance us because
they are superb photographs of Agony, conforming to sur-
realist standards of beauty. Smith's photograph of a dying youth
writhing on his mother's lap is a Pietà for the world of plague
victims which Artaud invokes as the true subject of modern
dramaturgy; indeed, the whole series of photographs are pos-
sible images for Artaud's Theater of Cruelty.

Because each photograph is only a fragment, its moral and
emotional weight depends on where it is inserted. A photo-
graph changes according to the context in which it is seen:

thus Smith's Minamata photographs will seem different on a contact sheet, in a gallery, in a political demonstration, in a police file, in a photographic magazine, in a general news magazine, in a book, on a living-room wall. Each of these situations suggests a different use for the photographs but none can secure their meaning. As Wittgenstein argued for words, that the meaning *is* the use—so for each photograph. And it is in this way that the presence and proliferation of all photographs contributes to the erosion of the very notion of meaning, to that parceling out of the truth into relative truths which is taken for granted by the modern liberal consciousness.

Socially concerned photographers assume that their work can convey some kind of stable meaning, can reveal truth. But partly because the photograph is, always, an object in a context, this meaning is bound to drain away; that is, the context which shapes whatever immediate—in particular, political—uses the photograph may have is inevitably succeeded by contexts in which such uses are weakened and become progressively less relevant. One of the central characteristics of photography is that process by which original uses are modified, eventually supplanted by subsequent uses—most notably, by the discourse of art into which any photograph can be absorbed. And, being images themselves, some photographs right from the start refer us to other images as well as to life. The photograph that the Bolivian authorities transmitted to the world press in October 1967 of Che Guevara's body, laid out in a stable on a stretcher on top

of a cement trough, surrounded by a Bolivian colonel, a U.S. intelligence agent, and several journalists and soldiers, not only summed up the bitter realities of contemporary Latin American history but had some inadvertent resemblance, as John Berger has pointed out, to Mantegna's "The Dead Christ" and Rembrandt's "The Anatomy Lesson of Professor Tulp." What is compelling about the photograph partly derives from what it shares, as a composition, with these paintings. Indeed, the very extent to which that photograph is unforgettable indicates its potential for being depoliticized, for becoming a timeless image.

The best writing on photography has been by moralists—Marxists or would-be Marxists—hooked on photographs but troubled by the way photography inexorably beautifies. As Walter Benjamin observed in 1934, in an address delivered in Paris at the Institute for the Study of Fascism, the camera

is now incapable of photographing a tenement or a rubbish heap without transfiguring it. Not to mention a river dam or an electric cable factory: in front of these, photography can only say, 'How beautiful.' . . . It has succeeded in turning abject poverty itself, by handling it in a modish, technically perfect way, into an object of enjoyment.

Moralists who love photographs always hope that words will save the picture. (The opposite approach to that of the museum curator who, in order to turn a photojournalist's

work into art, shows the photographs without their original captions.) Thus, Benjamin thought that the right caption beneath a picture could "rescue it from the ravages of mod-ishness and confer upon it a revolutionary use value." He urged that writers start taking photographs, to show the way.

Socially concerned writers have not taken to cameras, but they are often enlisted, or volunteer, to spell out the truth to which photographs testify—as James Agee did in the texts he wrote to accompany Walker Evans's photographs in *Let Us Now Praise Famous Men*, or as John Berger did in his essay on the photograph of the dead Che Guevara, this essay being in effect an extended caption, one that attempts to firm up the political associations and moral meaning of a photograph that Berger found too satisfying aesthetically, too suggestive iconographically. Godard and Gorin's short film *A Letter to Jane* (1972) amounts to a kind of counter-caption to a photograph—a mordant criticism of a photograph of Jane Fonda taken during a visit to North Vietnam. (The film is also a model lesson on how to read any photograph, how to decipher the un-innocent nature of a photograph's framing, angle, focus.) What the photograph—it shows Fonda listen-ing with an expression of distress and compassion as an unidentified Vietnamese describes the ravages of American bombing—meant when it was published in the French pic-ture magazine *L'Express* in some ways reverses the meaning it had for the North Vietnamese, who released it. But even more decisive than how the photograph was changed by its new

setting is how its revolutionary use-value to the North Vietnamese was sabotaged by what *L'Express* furnished as a caption. "This photograph, like any photograph," Godard and Gorin point out, "is physically mute. It talks through the mouth of the text written beneath it." In fact, words do speak louder than pictures. Captions do tend to override the evidence of our eyes; but no caption can permanently restrict or secure a picture's meaning.

What the moralists are demanding from a photograph is that it do what no photograph can ever do—speak. The caption is the missing voice, and it is expected to speak for truth. But even an entirely accurate caption is only one interpretation, necessarily a limiting one, of the photograph to which it is attached. And the caption-glove slips on and off so easily. It cannot prevent any argument or moral plea which a photograph (or set of photographs) is intended to support from being undermined by the plurality of meanings that every photograph carries, or from being qualified by the acquisitive mentality implicit in all picture-taking—and picture-collecting—and by the aesthetic relation to their subjects which all photographs inevitably propose. Even those photographs which speak so laceratingly of a specific historical moment also give us vicarious possession of their subjects under the aspect of a kind of eternity: the beautiful. The photograph of Che Guevara is finally . . . beautiful, as was the man. So are the people of Minamata. So is the small Jewish boy photographed in 1943 during a round-up in the Warsaw

Ghetto, his arms raised, solemn with terror—whose picture the mute heroine of Bergman's *Persona* has brought with her to the mental hospital to meditate on, as a photo-souvenir of the essence of tragedy.

In a consumer society, even the most well-intentioned and properly captioned work of photographers issues in the discovery of beauty. The lovely composition and elegant perspective of Lewis Hine's photographs of exploited children in turn-of-the-century American mills and mines easily outlast the relevance of their subject matter. Protected middle-class inhabitants of the more affluent corners of the world—those regions where most photographs are taken and consumed—learn about the world's horrors mainly through the camera: photographs can and do distress. But the aestheticizing tendency of photography is such that the medium which conveys distress ends by neutralizing it. Cameras miniaturize experience, transform history into spectacle. As much as they create sympathy, photographs cut sympathy, distance the emotions. Photography's realism creates a confusion about the real which is (in the long run) analgesic morally as well as (both in the long and in the short run) sensorially stimulating. Hence, it clears our eyes. This is the fresh vision everyone has been talking about.

WHATEVER THE MORAL CLAIMS made on behalf of photography, its main effect is to convert the world into a department store or museum-without-walls in which every subject is

depreciated into an article of consumption, promoted into an item for aesthetic appreciation. Through the camera people become customers or tourists of reality—or *Réalités*, as the name of the French photo-magazine suggests, for reality is understood as plural, fascinating, and up for grabs. Bringing the exotic near, rendering the familiar and homely exotic, photographs make the entire world available as an object of appraisal. For photographers who are not confined to projecting their own obsessions, there are arresting moments, beautiful subjects everywhere. The most heterogeneous subjects are then brought together in the fictive unity offered by the ideology of humanism. Thus, according to one critic, the greatness of Paul Strand's pictures from the last period of his life—when he turned from the brilliant discoveries of the abstracting eye to the touristic, world-anthologizing tasks of photography—consists in the fact that "his people, whether Bowery derelict, Mexican peon, New England farmer, Italian peasant, French artisan, Breton or Hebrides fisherman, Egyptian fellahin, the village idiot or the great Picasso, are all touched by the same heroic quality—humanity." What is this humanity? It is a quality things have in common when they are viewed as photographs.

The urge to take photographs is in principle an indiscriminate one, for the practice of photography is now identified with the idea that everything in the world could be made interesting through the camera. But this quality of being interesting, like that of manifesting humanity, is an empty

one. The photographic purchase on the world, with its limitless production of notes on reality, makes everything homologous. Photography is no less reductive when it is being reportorial than when it reveals beautiful forms. By disclosing the thingness of human beings, the humanness of things, photography transforms reality into a tautology. When Cartier-Bresson goes to China, he shows that there are people in China, and that they are Chinese.

Photographs are often invoked as an aid to understanding and tolerance. In humanist jargon, the highest vocation of photography is to explain man to man. But photographs do not explain; they acknowledge. Robert Frank was only being honest when he declared that "to produce an authentic contemporary document, the visual impact should be such as will nullify explanation." If photographs are messages, the message is both transparent and mysterious. "A photograph is a secret about a secret," as Arbus observed. "The more it tells you the less you know." Despite the illusion of giving understanding, what seeing through photographs really invites is an acquisitive relation to the world that nourishes aesthetic awareness and promotes emotional detachment.

The force of a photograph is that it keeps open to scrutiny instants which the normal flow of time immediately replaces. This freezing of time—the insolent, poignant stasis of each photograph—has produced new and more inclusive canons of beauty. But the truths that can be rendered in a dissociated moment, however significant or decisive, have a very

narrow relation to the needs of understanding. Contrary to what is suggested by the humanist claims made for photography, the camera's ability to transform reality into something beautiful derives from its relative weakness as a means of conveying truth. The reason that humanism has become the reigning ideology of ambitious professional photographers—displacing formalist justifications of their quest for beauty—is that it masks the confusions about truth and beauty underlying the photographic enterprise.

Photographic Evangels

L ike other steadily aggrandizing enterprises, photography has inspired its leading practitioners with a need to explain, again and again, what they are doing and why it is valuable. The era in which photography was widely attacked (as parricidal with respect to painting, predatory with respect to people) was a brief one. Painting of course did not expire in 1839, as one French painter hastily predicted; the finicky soon ceased to dismiss photography as menial copying; and by 1854 a great painter, Delacroix, graciously declared how much he regretted that such an admirable invention came so late. Nothing is more acceptable today than the photographic recycling of reality, acceptable as an everyday activity and as a branch of high art. Yet something about photography still keeps the first-rate professionals defensive and hortatory: virtually every important photographer right up to the present has written manifestoes and credos expounding photography's moral and aesthetic mission. And photographers give the most contradictory accounts of what kind of knowledge they possess and what kind of art they practice.

*

THE DISCONCERTING EASE WITH which photographs can be taken, the inevitable even when inadvertent authority of the camera's results, suggest a very tenuous relation to knowing. No one would dispute that photography gave a tremendous boost to the cognitive claims of sight, because—through close-up and remote sensing—it so greatly enlarged the realm of the visible. But about the ways in which any subject within the range of unaided vision is further known through a photograph or the extent to which, in order to get a good photograph, people need to know anything about what they are photographing, there is no agreement. Picture-taking has been interpreted in two entirely different ways: either as a lucid and precise act of knowing, of conscious intelligence, or as a pre-intellectual, intuitive mode of encounter. Thus Nadar, speaking of his respectful, expressive pictures of Baudelaire, Doré, Michelet, Hugo, Berlioz, Nerval, Gautier, Sand, Delacroix, and other famous friends, said "the portrait I do best is of the person I know best," while Avedon has observed that most of his good portraits are of people he met for the first time when photographing them.

In this century, the older generation of photographers described photography as a heroic effort of attention, an ascetic discipline, a mystic receptivity to the world which requires that the photographer pass through a cloud of unknowing. According to Minor White, "the state of mind of the photographer while creating is a blank... when looking for pictures... The photographer projects himself into everything he sees,

identifying himself with everything in order to know it and to feel it better." Cartier-Bresson has likened himself to a Zen archer, who must *become* the target so as to be able to hit it; "thinking should be done beforehand and afterwards," he says, "never while actually taking a photograph." Thought is regarded as clouding the transparency of the photographer's consciousness, and as infringing on the autonomy of what is being photographed. Determined to prove that photographs could— and when they are good, always do—transcend literalness, many serious photographers have made of photography a noetic paradox. Photography is advanced as a form of knowing without knowing: a way of outwitting the world, instead of making a frontal attack on it.

But even when ambitious professionals disparage thinking—suspicion of the intellect being a recurrent theme in photographic apologetics—they usually want to assert how rigorous this permissive visualizing needs to be. "A photograph is not an accident—it is a concept," Ansel Adams insists. "The 'machine-gun' approach to photography—by which many negatives are made with the hope that one will be good—is fatal to serious results." To take a good photograph, runs the common claim, one must already see it. That is, the image must exist in the photographer's mind at or before the moment when the negative is exposed. Justifying photography has for the most part precluded admitting that the scattershot method, especially as used by someone experienced, may yield a thoroughly satisfactory result. But despite

their reluctance to say so, most photographers have always had—with good reason—an almost superstitious confidence in the lucky accident.

Lately, the secret is becoming avowable. As the defense of photography enters its present, retrospective phase, there is an increasing diffidence in claims about the alert, knowing state of mind that accomplished picture-taking presumes. The anti-intellectual declarations of photographers, commonplaces of modernist thinking in the arts, have prepared the way for the gradual tilt of serious photography toward a skeptical investigation of its own powers, a commonplace of modernist practice in the arts. Photography as knowledge is succeeded by photography as—photography. In sharp reaction against any ideal of authoritative representation, the most influential of the younger American photographers reject any ambition to pre-visualize the image and conceive their work as showing how different things look when photographed.

Where the claims of knowledge falter, the claims of creativity take up the slack. As if to refute the fact that many superb pictures are by photographers devoid of any serious or interesting intentions, the insistence that picture-taking is first of all the focusing of a temperament, only secondarily of a machine, has always been one of the main themes of the defense of photography. This is the theme stated so eloquently in the finest essay ever written in praise of photography, Paul Rosenfeld's chapter on Stieglitz in *Port of New York*. By using

"his machinery"—as Rosenfeld puts it—"unmechanically," Stieglitz shows that the camera not only "gave him an opportunity of expressing himself" but supplied images with a wider and "more delicate" gamut "than the hand can draw." Similarly, Weston insists over and over that photography is a supreme opportunity for self-expression, far superior to that offered by painting. For photography to compete with painting means invoking originality as an important standard for appraising a photographer's work, originality being equated with the stamp of a unique, forceful sensibility. What is exciting "are photographs that say something in a new manner," Harry Callahan writes, "*not* for the sake of being different, but because the individual is different and the individual expresses himself." For Ansel Adams "a great photograph" has to be "a full expression of what one feels about what is being photographed in the deepest sense and is, thereby, a true expression of what one feels about life in its entirety."

That there is a difference between photography conceived as "true expression" and photography conceived (as it more commonly is) as faithful recording is evident; though most accounts of photography's mission attempt to paper over the difference, it is implicit in the starkly polarized terms that photographers employ to dramatize what they do. As modern forms of the quest for self-expression commonly do, photography recapitulates both of the traditional ways of radically opposing self and world. Photography is seen as an acute manifestation of the individualized "I," the homeless private self astray in an

overwhelming world—mastering reality by a fast visual anthologizing of it. Or photography is seen as a means of finding a place in the world (still experienced as overwhelming, alien) by being able to relate to it with detachment—bypassing the interfering, insolent claims of the self. But between the defense of photography as a superior means of self-expression and the praise of photography as a superior way of putting the self at reality's service there is not as much difference as might appear. Both presuppose that photography provides a unique system of disclosures: that it shows us reality as we had *not* seen it before.

This revelatory character of photography generally goes by the polemical name of realism. From Fox Talbot's view that the camera produces "natural images" to Berenice Abbott's denunciation of "pictorial" photography to Cartier-Bresson's warning that "the thing to be feared most is the artificially contrived," most of the contradictory declarations of photographers converge on pious avowals of respect for things-as-they-are. For a medium so often considered to be merely realistic, one would think photographers would not have to go on as they do, exhorting each other to stick to realism. But the exhortations continue—another instance of the need photographers have for making something mysterious and urgent of the process by which they appropriate the world.

To insist, as Abbott does, that realism is the very essence of photography does not, as it might seem, establish the superiority of one particular procedure or standard; does not

necessarily mean that photo-documents (Abbott's word) are better than pictorial photographs.* Photography's commitment to realism can accommodate any style, any approach to subject matter. Sometimes it will be defined more narrowly, as the making of images which resemble, and inform us about, the world. Interpreted more broadly, echoing the distrust of mere likeness which has inspired painting for more than a century, photographic realism can be—is more and more—defined not as what is "really" there but as what I "really" perceive. While all modern forms of art claim some privileged relation to reality, the claim seems particularly justified in the case of photography. Yet photography has not, finally, been any more immune than painting has to the most characteristic modern doubts about any straightforward relation to reality—the inability to take for granted the world as observed. Even Abbott cannot help assuming a change in the very nature of reality: that it needs the selective, more acute eye of the camera, there being simply much more of it than ever before. "Today, we are confronted with reality on

*The original meaning of pictorial was, of course, the positive one popularized by the most famous of the nineteenth-century art photographers, Henry Peach Robinson, in his book *Pictorial Effect in Photography* (1869). "His system was to flatter everything," Abbott says in a manifesto she wrote in 1951, "Photography at the Crossroads." Praising Nadar, Brady, Atget, and Hine as masters of the photo-document, Abbott dismisses Stieglitz as Robinson's heir, founder of a "super-pictorial school" in which, once again, "subjectivity predominated."

the vastest scale mankind has known," she declares, and this puts "a greater responsibility on the photographer."

All that photography's program of realism actually implies is the belief that reality is hidden. And, being hidden, is something to be unveiled. Whatever the camera records is a disclosure—whether it is imperceptible, fleeting parts of movement, an order that natural vision is incapable of perceiving or a "heightened reality" (Moholy-Nagy's phrase), or simply the elliptical way of seeing. What Stieglitz describes as his "patient waiting for the moment of equilibrium" makes the same assumption about the essential hiddenness of the real as Robert Frank's waiting for the moment of revealing disequilibrium, to catch reality off-guard, in what he calls the "in-between moments."

Just to show something, anything, in the photographic view is to show that it is hidden. But it is not necessary for photographers to point up the mystery with exotic or exceptionally striking subjects. When Dorothea Lange urges her colleagues to concentrate on "the familiar," it is with the understanding that the familiar, rendered by a sensitive use of the camera, will thereby become mysterious. Photography's commitment to realism does not limit photography to certain subjects, as more real than others, but rather illustrates the formalist understanding of what goes on in every work of art: reality is, in Viktor Shklovsky's word, de-familiarized. What is being urged is an aggressive relation to all subjects. Armed with their machines, photographers are to make an assault on reality—which is

perceived as recalcitrant, as only deceptively available, as unreal. "The pictures have a reality for me that the people don't," Avedon has declared. "It is through the photographs that I know them." To claim that photography must be realistic is not incompatible with opening up an even wider gap between image and reality, in which the mysteriously acquired knowledge (and the enhancement of reality) supplied by photographs presumes a prior alienation from or devaluation of reality.

As photographers describe it, picture-taking is both a limitless technique for appropriating the objective world and an unavoidably solipsistic expression of the singular self. Photographs depict realities that already exist, though only the camera can disclose them. And they depict an individual temperament, discovering itself through the camera's cropping of reality. For Moholy-Nagy the genius of photography lies in its ability to render "an objective portrait: the individual to be photographed so that the photographic result shall not be encumbered with subjective intention." For Lange every portrait of another person is a "self-portrait" of the photographer, as for Minor White—promoting "self-discovery through a camera"—landscape photographs are really "inner landscapes." The two ideals are antithetical. Insofar as photography is (or should be) about the world, the photographer counts for little, but insofar as it is the instrument of intrepid, questing subjectivity, the photographer is all.

Moholy-Nagy's demand for the photographer's self-effacement follows from his appreciation of how edifying

photography is: it retains and upgrades our powers of observation, it brings about "a psychological transformation of our eyesight." (In an essay published in 1936, he says that photography creates or enlarges eight distinct varieties of seeing: abstract, exact, rapid, slow, intensified, penetrative, simultaneous, and distorted.) But self-effacement is also the demand behind quite different, anti-scientific approaches to photography, such as that expressed in Robert Frank's credo: "There is one thing the photograph must contain, the humanity of the moment." In both views the photographer is proposed as a kind of ideal observer—for Moholy-Nagy, seeing with the detachment of a researcher; for Frank, seeing "simply, as through the eyes of the man in the street."

One attraction of any view of the photographer as ideal observer—whether impersonal (Moholy-Nagy) or friendly (Frank)—is that it implicitly denies that picture-taking is in any way an aggressive act. That it can be so described makes most professionals extremely defensive. Cartier-Bresson and Avedon are among the very few to have talked honestly (if ruefully) about the exploitative aspect of the photographer's activities. Usually photographers feel obliged to protest photography's innocence, claiming that the predatory attitude is incompatible with a good picture, and hoping that a more affirmative vocabulary will put over their point. One of the more memorable examples of such verbiage is Ansel Adams's description of the camera as an "instrument of love and revelation"; Adams also urges that we stop saying that we "take"

a picture and always say we "make" one. Stieglitz's name for the cloud studies he did in the late 1920s—"Equivalents," that is, statements of his inner feelings—is another, soberer instance of the persistent effort of photographers to feature the benevolent character of picture-taking and discount its predatory implications. What talented photographers do cannot of course be characterized either as simply predatory or as simply, and essentially, benevolent. Photography is the paradigm of an inherently equivocal connection between self and world—its version of the ideology of realism sometimes dictating an effacement of the self in relation to the world, sometimes authorizing an aggressive relation to the world which celebrates the self. One side or the other of the connection is always being rediscovered and championed.

An important result of the coexistence of these two ideals—assault on reality and submission to reality—is a recurrent ambivalence toward photography's *means*. Whatever the claims for photography as a form of personal expression on a par with painting, it remains true that its originality is inextricably linked to the powers of the machine: no one can deny the informativeness and formal beauty of many photographs made possible by the steady growth of these powers, like Harold Edgerton's high-speed photographs of a bullet hitting its target, of the swirls and eddies of a tennis stroke, or Lennart Nilsson's endoscopic photographs of the interior of the human body. But as cameras get ever more sophisticated, more automated, more acute, some photographers are tempted to

disarm themselves or to suggest that they are really not armed, and prefer to submit themselves to the limits imposed by a pre-modern camera technology—a cruder, less high-powered machine being thought to give more interesting or expressive results, to leave more room for the creative accident. Not using fancy equipment has been a point of honor for many photographers—including Weston, Brandt, Evans, Cartier-Bresson, Frank—some sticking with a battered camera of simple design and slow lens that they acquired early in their careers, some continuing to make their contact prints with nothing more elaborate than a few trays, a bottle of developer, and a bottle of hypo solution.

The camera is indeed the instrument of "fast seeing," as one confident modernist, Alvin Langdon Coburn, declared in 1918, echoing the Futurist apotheosis of machines and speed. Photography's present mood of doubt can be gauged by Cartier-Bresson's recent statement that it may be *too* fast. The cult of the future (of faster and faster seeing) alternates with the wish to return to a more artisanal, purer past—when images still had a handmade quality, an aura. This nostalgia for some pristine state of the photographic enterprise underlies the current enthusiasm for daguerreotypes, stereograph cards, photographic *cartes de visite*, family snapshots, the work of forgotten nineteenth- and early-twentieth-century provincial and commercial photographers.

But the reluctance to use the newest high-powered equipment is not the only or indeed the most interesting way in

which photographers express their attraction to photography's past. The primitivist hankerings that inform current photographic taste are actually being aided by the ceaseless innovativeness of camera technology. For many of these advances not only enlarge the camera's powers but also recapitulate—in a more ingenious, less cumbersome form—earlier, discarded possibilities of the medium. Thus, the development of photography hinges on the replacement of the daguerreotype process, direct positives on metal plates, by the positive-negative process, whereby from an original (negative) an unlimited number of prints (positives) can be made. (Although invented simultaneously in the late 1830s, it was Daguerre's government-supported invention, announced in 1839 with great publicity, rather than Fox Talbot's positive-negative process, that was the first photographic process in general use.) But now the camera could be said to be turning back upon itself. The Polaroid camera revives the principle of the daguerreotype camera: each print is a unique object. The hologram (a three-dimensional image created with laser light) could be considered as a variant on the heliogram—the first, cameraless photographs made in the 1820s by Nicéphore Niépce. And the increasingly popular use of the camera to produce slides—images which cannot be displayed permanently or stored in wallets and albums, but can only be projected on walls or on paper (as aids for drawing)—goes back even further into the camera's pre-history, for it amounts to using the photographic camera to do the work of the camera obscura.

"History is pushing us to the brink of a realistic age," according to Abbott, who summons photographers to make the jump themselves. But while photographers are perpetually urging each other to be bolder, a doubt persists about the value of realism which keeps them oscillating between simplicity and irony, between insisting on control and cultivating the unexpected, between the eagerness to take advantage of the complex evolution of the medium and the wish to reinvent photography from scratch. Photographers seem to need periodically to resist their own knowingness and to remystify what they do.

QUESTIONS ABOUT KNOWLEDGE ARE not, historically, photography's first line of defense. The earliest controversies center on the question whether photography's fidelity to appearances and dependence on a machine did not prevent it from being a fine art—as distinct from a merely practical art, an arm of science, and a trade. (That photographs give useful and often startling kinds of information was obvious from the beginning. Photographers only started worrying about what they knew, and what kind of knowledge in a deeper sense a photograph supplies, *after* photography was accepted as an art.) For about a century the defense of photography was identical with the struggle to establish it as a fine art. Against the charge that photography was a soulless, mechanical copying of reality, photographers asserted that it was a vanguard revolt against ordinary standards of seeing, no less worthy an art than painting.

Now photographers are choosier about the claims they make. Since photography has become so entirely respectable as a branch of the fine arts, they no longer seek the shelter that the notion of art has intermittently given the photographic enterprise. For all the important American photographers who have proudly identified their work with the aims of art (like Stieglitz, White, Siskind, Callahan, Lange, Laughlin), there are many more who disavow the question itself. Whether or not the camera's "results come under the category of Art is irrelevant," Strand wrote in the 1920s; and Moholy-Nagy declared it "quite unimportant whether photography produces 'art' or not." Photographers who came to maturity in the 1940s or later are bolder, openly snubbing art, equating art with artiness. They generally claim to be finding, recording, impartially observing, witnessing, exploring themselves—anything but making works of art. At first, it was photography's commitment to realism that placed it in a permanently ambivalent relation to art; now it is its modernist heritage. The fact that important photographers are no longer willing to debate whether photography is or is not a fine art, except to proclaim that their work is *not* involved with art, shows the extent to which they simply take for granted the concept of art imposed by the triumph of modernism: the better the art, the more subversive it is of the traditional aims of art. And modernist taste has welcomed this unpretentious activity that can be consumed, almost in spite of itself, as high art.

Even in the nineteenth century, when photography was

thought to be so evidently in need of defense as a fine art, the line of defense was far from stable. Julia Margaret Cameron's claim that photography qualifies as an art because, like painting, it seeks the beautiful was succeeded by Henry Peach Robinson's Wildean claim that photography is an art because it can lie. In the early twentieth century Alvin Langdon Coburn's praise of photography as "the most modern of the arts," because it is a fast, impersonal way of seeing, competed with Weston's praise of photography as a new means of individual visual creation. In recent decades the notion of art has been exhausted as an instrument of polemic; indeed, a good part of the immense prestige that photography has acquired as an art form comes from its declared ambivalence toward being an art. When photographers now deny that they are making works of art, it is because they think they are doing something better than that. Their disclaimers tell us more about the harried status of any notion of art than about whether photography is or isn't one.

Despite the efforts of contemporary photographers to exorcise the specter of art, something lingers. For instance, when professionals object to having their photographs printed to the edge of the page in books or magazines, they are invoking the model inherited from another art: as paintings are put in frames, photographs should be framed in white space. Another instance: many photographers continue to prefer black-and-white images, which are felt to be more tactful, more decorous than color—or less voyeuristic and less

sentimental or crudely lifelike. But the real basis for this preference is, once again, an implicit comparison with painting. In the introduction to his book of photographs *The Decisive Moment* (1952), Cartier-Bresson justified his unwillingness to use color by citing technical limitations: the slow speed of color film, which reduces the depth of focus. But with the rapid progress in color-film technology during the last two decades, making possible all the tonal subtlety and high resolution one might desire, Cartier-Bresson has had to shift his ground, and now proposes that photographers renounce color as a matter of principle. In Cartier-Bresson's version of that persistent myth according to which—following the camera's invention—a division of territory took place between photography and painting, color belongs to painting. He enjoins photographers to resist temptation and keep up their side of the bargain.

Those still involved in defining photography as an art are always trying to hold some line. But it is impossible to hold the line: any attempt to restrict photography to certain subjects or certain techniques, however fruitful these have proved to be, is bound to be challenged and to collapse. For it is in the very nature of photography that it be a promiscuous form of seeing, and, in talented hands, an infallible medium of creation. (As John Szarkowski observes, "a skillful photographer can photograph anything well.") Hence, its longstanding quarrel with art, which (until recently) meant the results of a discriminating or purified way of

seeing, and a medium of creation governed by standards that make genuine achievement a rarity. Understandably, photographers have been reluctant to give up the attempt to define more narrowly what good photography is. The history of photography is punctuated by a series of dualistic controversies—such as the straight print versus the doctored print, pictorial photography versus documentary photography—each of which is a different form of the debate about photography's relation to art: how close it can get while still retaining its claim to unlimited visual acquisition. Recently, it has become common to maintain that all these controversies are now outmoded, which suggests that the debate has been settled. But it is unlikely that the defense of photography as art will ever completely subside. As long as photography is not only a voracious way of seeing but one which needs to claim that it is a special, distinctive way, photographers will continue to take shelter (if only covertly) in the defiled but still prestigious precincts of art.

Photographers who suppose they are getting away from the pretensions of art as exemplified in painting by taking pictures remind us of those Abstract Expressionist painters who imagined they were getting away from art, or Art, by the act of painting (that is, by treating the canvas as a field of action rather than as an object). And much of the prestige that photography has recently acquired as an art is based on the convergence of its claims with those of more recent painting

and sculpture.* The seemingly insatiable appetite for photography in the 1970s expresses more than the pleasure of discovering and exploring a relatively neglected art form; it derives much of its fervor from the desire to reaffirm the dismissal of abstract art which was one of the messages of the pop taste of the 1960s. Paying more and more attention to photographs is a great relief to sensibilities tired of, or eager to avoid, the mental exertions demanded by abstract art. Classical modernist painting presupposes highly developed skills of looking, and a familiarity with other art and with certain notions about the history of art. Photography, like pop art, reassures viewers that art isn't hard; it seems to be more about subjects than about art.

Photography is the most successful vehicle of modernist taste in its pop version, with its zeal for debunking the high

*The claims of photography are, of course, much older. For the now familiar practice that substitutes encounter for fabrication, found objects or situations for made (or made-up) ones, decision for effort, the prototype is photography's instant art through the mediation of a machine. It was photography that first put into circulation the idea of an art that is produced not by pregnancy and childbirth but by a blind date (Duchamp's theory of "rendez-vous"). But professional photographers are much less secure than their Duchamp-influenced contemporaries in the established fine arts, and generally hasten to point out that a moment's decision presupposes a long training of sensibility, of the eye, and to insist that the effortlessness of picture-taking does not make the photographer any less of an artificer than a painter.

culture of the past (focusing on shards, junk, odd stuff; excluding nothing); its conscientious courting of vulgarity; its affection for kitsch; its skill in reconciling avant-garde ambitions with the rewards of commercialism; its pseudo-radical patronizing of art as reactionary, elitist, snobbish, insincere, artificial, out of touch with the broad truths of everyday life; its transformation of art into cultural document. At the same time, photography has gradually acquired all the anxieties and self-consciousness of a classic modernist art. Many professionals are now worried that this populist strategy is being carried too far, and that the public will forget that photography is, after all, a noble and exalted activity—in short, an art. For the modernist promotion of naïve art always contains a joker: that one continue to honor its hidden claim to sophistication.

IT CANNOT BE A coincidence that just about the time that photographers stopped discussing whether photography is an art, it was acclaimed as one by the general public and photography entered, in force, into the museum. The museum's naturalization of photography as art is the conclusive victory of the century-long campaign waged by modernist taste on behalf of an open-ended definition of art, photography offering a much more suitable terrain than painting for this effort. For the line between amateur and professional, primitive and sophisticated is not just harder to draw with photography than it is with painting—it has little meaning. Naïve or

commercial or merely utilitarian photography is no different in kind from photography as practiced by the most gifted professionals: there are pictures taken by anonymous amateurs which are just as interesting, as complex formally, as representative of photography's characteristic powers as a Stieglitz or an Evans.

That all the different kinds of photography form one continuous and interdependent tradition is the once startling, now obvious-seeming assumption which underlies contemporary photographic taste and authorizes the indefinite expansion of that taste. To make this assumption only became plausible when photography was taken up by curators and historians and regularly exhibited in museums and art galleries. Photography's career in the museum does not reward any particular style; rather, it presents photography as a collection of simultaneous intentions and styles which, however different, are not perceived as in any way contradictory. But while the operation has been a huge success with the public, the response of photography professionals is mixed. Even as they welcome photography's new legitimacy, many of them feel threatened when the most ambitious images are discussed in direct continuity with *all* sorts of images, from photojournalism to scientific photography to family snapshots—charging that this reduces photography to something trivial, vulgar, a mere craft.

The real problem with bringing functional photographs, photographs taken for a practical purpose, on commercial

assignment, or as souvenirs, into the mainstream of photographic achievement is not that it demeans photography, considered as a fine art, but that the procedure contradicts the nature of most photographs. In most uses of the camera, the photograph's naïve or descriptive function is paramount. But when viewed in their new context, the museum or gallery, photographs cease to be "about" their subjects in the same direct or primary way; they become studies in the possibilities of photography. Photography's adoption by the museum makes photography itself seem problematic, in the way experienced only by a small number of self-conscious photographers whose work consists precisely in questioning the camera's ability to grasp reality. The eclectic museum collections reinforce the arbitrariness, the subjectivity of all photographs, including the most straightforwardly descriptive ones.

Putting on shows of photographs has become as featured a museum activity as mounting shows of individual painters. But a photographer is not like a painter, the role of the photographer being recessive in much of serious picture-taking and virtually irrelevant in all the ordinary uses. So far as we care about the subject photographed, we expect the photographer to be an extremely discreet presence. Thus, the very success of photojournalism lies in the difficulty of distinguishing one superior photographer's work from another's, except insofar as he or she has monopolized a particular subject. These photographs have their power as images (or copies) of the world, not of an individual artist's consciousness. And

in the vast majority of photographs which get taken—for scientific and industrial purposes, by the press, by the military and the police, by families—any trace of the personal vision of whoever is behind the camera interferes with the primary demand on the photograph: that it record, diagnose, inform.

It makes sense that a painting is signed but a photograph is not (or it seems bad taste if it is). The very nature of photography implies an equivocal relation to the photographer as *auteur*; and the bigger and more varied the work done by a talented photographer, the more it seems to acquire a kind of corporate rather than individual authorship. Many of the published photographs by photography's greatest names seem like work that could have been done by another gifted professional of their period. It requires a formal conceit (like Todd Walker's solarized photographs or Duane Michals's narrative-sequence photographs) or a thematic obsession (like Eakins with the male nude or Laughlin with the Old South) to make work easily recognizable. For photographers who don't so limit themselves, their body of work does not have the same integrity as does comparably varied work in other art forms. Even in those careers with the sharpest breaks of period and style— think of Picasso, of Stravinsky—one can perceive the unity of concerns that transcends these breaks and can (retrospectively) see the inner relation of one period to another. Knowing the whole body of work, one can see how the same composer could have written *Le Sacre du printemps*, the Dumbarton Oaks Concerto, and the late neo-Schoenbergian works; one

recognizes Stravinsky's hand in all these compositions. But there is no internal evidence for identifying as the work of a single photographer (indeed, one of the most interesting and original of photographers) those studies of human and animal motion, the documents brought back from photo-expeditions in Central America, the government-sponsored camera surveys of Alaska and Yosemite, and the "Clouds" and "Trees" series. Even after knowing they were all taken by Muybridge, one still can't relate these series of pictures to each other (though each series has a coherent, recognizable style), any more than one could infer the way Atget photographed trees from the way he photographed Paris shop windows, or connect Roman Vishniac's pre-war portraits of Polish Jews with the scientific microphotographs he has been taking since 1945. In photography the subject matter always pushes through, with different subjects creating unbridgeable gaps between one period and another of a large body of work, confounding signature.

Indeed, the very presence of a coherent photographic style—think of the white backgrounds and flat lighting of Avedon's portraits, of the distinctive grisaille of Atget's Paris street studies—seems to imply unified material. And subject matter seems to have the largest part in shaping a viewer's preferences. Even when photographs are isolated from the practical context in which they may originally have been taken, and looked at as works of art, to prefer one photograph to another seldom means only that the photograph is judged

to be superior formally; it almost always means—as in more casual kinds of looking—that the viewer prefers that kind of mood, or respects that intention, or is intrigued by (or feels nostalgic about) that subject. The formalist approaches to photography cannot account for the power of *what* has been photographed, and the way distance in time and cultural distance from the photograph increase our interest.

Still, it seems logical that contemporary photographic taste has taken a largely formalist direction. Although the natural or naïve status of subject matter in photography is more secure than in any other representational art, the very plurality of situations in which photographs are looked at complicates and eventually weakens the primacy of subject matter. The conflict of interest between objectivity and subjectivity, between demonstration and supposition, is unresolvable. While the authority of a photograph will always depend on the relation to a subject (that it is a photograph *of* something), all claims on behalf of photography as art must emphasize the subjectivity of seeing. There is an equivocation at the heart of all aesthetic evaluations of photographs; and this explains the chronic defensiveness and extreme mutability of photographic taste.

For a brief time—say, from Stieglitz through the reign of Weston—it appeared that a solid point of view had been erected with which to evaluate photographs: impeccable lighting, skill of composition, clarity of subject, precision of focus, perfection of print quality. But this position, generally

thought of as Westonian—essentially technical criteria for what makes a photograph good—is now bankrupt. (Weston's deprecating appraisal of the great Atget as "not a fine technician" shows its limitations.) What position has replaced Weston's? A much more inclusive one, with criteria which shift the center of judgment from the individual photograph, considered as a finished object, to the photograph considered as an example of "photographic seeing." What is meant by photographic seeing would hardly exclude Weston's work but it would also include a large number of anonymous, unposed, crudely lit, asymmetrically composed photographs formerly dismissed for their lack of composition. The new position aims to liberate photography, as art, from the oppressive standards of technical perfection; to liberate photography from beauty, too. It opens up the possibility of a global taste, in which no subject (or absence of subject), no technique (or absence of technique) disqualifies a photograph.

While in principle all subjects are worthy pretexts for exercising the photographic way of seeing, the convention has arisen that photographic seeing is clearest in offbeat or trivial subject matter. Subjects are chosen because they are boring or banal. Because we are indifferent to them, they best show up the ability of the camera to "see." When Irving Penn, known for his handsome photographs of celebrities and food for fashion magazines and ad agencies, was given a show at the Museum of Modern Art in 1975, it was for a series of close-ups of cigarette butts. "One might guess," commented the

director of the museum's Department of Photography, John Szarkowski, "that [Penn] has only rarely enjoyed more than a cursory interest in the nominal subjects of his pictures." Writing about another photographer, Szarkowski commends what can "be coaxed from subject matter" that is "profoundly banal." Photography's adoption by the museum is now firmly associated with those important modernist conceits: the "nominal subject" and the "profoundly banal." But this approach not only diminishes the importance of subject matter; it also loosens the photograph from its connection with a single photographer. The photographic way of seeing is far from exhaustively illustrated by the many one-photographer shows and retrospectives that museums now put on. To be legitimate as an art, photography must cultivate the notion of the photographer as *auteur* and of all photographs taken by the same photographer as constituting a body of work. These notions are easier to apply to some photographers than to others. They seem more applicable to, say, Man Ray, whose style and purposes straddle photographic and painterly norms, than to Steichen, whose work includes abstractions, portraits, ads for consumer goods, fashion photographs, and aerial reconnaissance photographs (taken during his military career in both world wars). But the meanings that a photograph acquires when seen as part of an individual body of work are not particularly to the point when the criterion is photographic seeing. Rather, such an approach must necessarily favor the new meanings that any one picture acquires

when juxtaposed—in ideal anthologies, either on museum walls or in books—with the work of other photographers.

Such anthologies are meant to educate taste about photography in general; to teach a form of seeing which makes all subjects equivalent. When Szarkowski describes gas stations, empty living rooms, and other bleak subjects as "patterns of random facts in the service of [the photographer's] imagination," what he really means is that these subjects are ideal for the camera. The ostensibly formalist, neutral criteria of photographic seeing are in fact powerfully judgmental about subjects and about styles. The revaluation of naïve or casual nineteenth-century photographs, particularly those which were taken as humble records, is partly due to their sharp-focus style—a pedagogic corrective to the "pictorial" soft focus which, from Cameron to Stieglitz, was associated with photography's claim to be an art. Yet the standards of photographic seeing do not imply an unalterable commitment to sharp focus. Whenever serious photography is felt to have been purged of outmoded relations to art and to prettiness, it could just as well accommodate a taste for pictorial photography, for abstraction, for noble subjects rather than cigarette butts and gas stations and turned backs.

THE LANGUAGE IN WHICH photographs are generally evaluated is extremely meager. Sometimes it is parasitical on the vocabulary of painting: composition, light, and so forth. More often it consists in the vaguest sorts of judgments, as when

photographs are praised for being subtle, or interesting, or powerful, or complex, or simple, or—a favorite—deceptively simple.

The reason the language is poor is not fortuitous: say, the absence of a rich tradition of photographic criticism. It is something inherent in photography itself, whenever it is viewed as an art. Photography proposes a process of imagination and an appeal to taste quite different from that of painting (at least as traditionally conceived). Indeed, the difference between a good photograph and a bad photograph is not at all like the difference between a good and a bad painting. The norms of aesthetic evaluation worked out for painting depend on criteria of authenticity (and fakeness), and of craftsmanship—criteria that are more permissive or simply non-existent for photography. And while the tasks of connoisseurship in painting invariably presume the organic relation of a painting to an individual body of work with its own integrity, and to schools and iconographical traditions, in photography a large individual body of work does not necessarily have an inner stylistic coherence, and an individual photographer's relation to schools of photography is a much more superficial affair.

One criterion of evaluation which painting and photography do share is innovativeness; both paintings and photographs are often valued because they impose new formal schemes or changes in the visual language. Another criterion which they can share is the quality of presence, which Walter Benjamin

considered the defining characteristic of the work of art. Benjamin thought that a photograph, being a mechanically reproduced object, could not have genuine presence. It could be argued, however, that the very situation which is now determinative of taste in photography, its exhibition in museums and galleries, has revealed that photographs do possess a kind of authenticity. Furthermore, although no photograph is an original in the sense that a painting always is, there is a large qualitative difference between what could be called originals—prints made from the original negative at the time (that is, at the same moment in the technological evolution of photography) that the picture was taken—and subsequent generations of the same photograph. (What most people know of the famous photographs—in books, newspapers, magazines, and so forth—are photographs of photographs; the originals, which one is likely to see only in a museum or a gallery, offer visual pleasures which are not reproducible.) The result of mechanical reproduction, Benjamin says, is to "put the copy of the original into situations which would be out of reach for the original itself." But to the extent that, say, a Giotto can still be said to possess an aura in the situation of museum display, where it too has been wrenched from its original context and, like the photograph, "meets the beholder halfway" (in the strictest sense of Benjamin's notion of the aura, it does not), to that extent an Atget photograph printed on the now unobtainable paper he used can also be said to possess an aura.

The real difference between the aura that a photograph can have and that of a painting lies in the different relation to time. The depredations of time tend to work against paintings. But part of the built-in interest of photographs, and a major source of their aesthetic value, is precisely the transformations that time works upon them, the way they escape the intentions of their makers. Given enough time, many photographs do acquire an aura. (The fact that color photographs don't age in the way black-and-white photographs do may partly explain the marginal status which color has had until very recently in serious photographic taste. The cold intimacy of color seems to seal off the photograph from patina.) For while paintings or poems do not get better, more attractive simply because they are older, all photographs are interesting as well as touching if they are old enough. It is not altogether wrong to say that there is no such thing as a bad photograph—only less interesting, less relevant, less mysterious ones. Photography's adoption by the museum only accelerates that process which time will bring about anyway: making all work valuable.

The role of the museum in forming contemporary photographic taste cannot be overestimated. Museums do not so much arbitrate what photographs are good or bad as offer new conditions for looking at all photographs. This procedure, which appears to be creating standards of evaluation, in fact abolishes them. The museum cannot be said to have created a secure canon for the photographic work of the past, as

it has for painting. Even as it seems to be sponsoring a particular photographic taste, the museum is undermining the very idea of normative taste. Its role is to show that there are *no* fixed standards of evaluation, that there is *no* canonical tradition of work. Under the museum's attentions, the very idea of a canonical tradition is exposed as redundant.

What keeps photography's Great Tradition always in flux, constantly being reshuffled, is not that photography is a new art and therefore somewhat insecure—this is part of what photographic taste is about. There is a more rapid sequence of rediscovery in photography than in any other art. Illustrating that law of taste given its definitive formulation by T. S. Eliot whereby each important new work necessarily alters our perception of the heritage of the past, new photographs change how we look at past photographs. (For example, Arbus's work has made it easier to appreciate the greatness of the work of Hine, another photographer devoted to portraying the opaque dignity of victims.) But the swings in contemporary photographic taste do not only reflect such coherent and sequential processes of reevaluation, whereby like enhances like. What they more commonly express is the complementarity and equal value of antithetical styles and themes.

For several decades American photography has been dominated by a reaction against "Westonism"—that is, against contemplative photography, photography considered as an independent visual exploration of the world with no evident

social urgency. The technical perfection of Weston's photographs, the calculated beauties of White and Siskind, the poetic constructions of Frederick Sommer, the self-assured ironies of Cartier-Bresson—all these have been challenged by photography that is, at least programmatically, more naïve, more direct; that is hesitant, even awkward. But taste in photography is not that linear. Without any weakening of the current commitments to informal photography and to photography as social document, a perceptible revival of Weston is now taking place—as, with the passage of enough time, Weston's work no longer looks timeless; as, by the much broader definition of naïveté with which photographic taste operates, Weston's work also looks naïve.

Finally, there is no reason to exclude any photographer from the canon. Right now there are mini-revivals of such long-despised pictorialists from another era as Oscar Gustav Rejlander, Henry Peach Robinson, and Robert Demachy. As photography takes the whole world as its subject, there is room for every kind of taste. Literary taste does exclude: the success of the modernist movement in poetry elevated Donne but diminished Dryden. With literature, one can be eclectic up to a point, but one can't like everything. With photography, eclecticism has no limits. The plain photographs from the 1870s of abandoned children admitted to a London institution called Doctor Barnardo's Home (taken as "records") are as moving as David Octavius Hill's complex portraits of

Scottish notables of the 1840s (taken as "art"). The clean look of Weston's classic modern style is not refuted by, say, Benno Friedman's ingenious recent revival of pictorial blurriness.

This is not to deny that each viewer likes the work of some photographers more than others: for example, most experienced viewers today prefer Atget to Weston. What it does mean is that, by the nature of photography, one is not really obliged to choose; and that preferences of that sort are, for the most part, merely reactive. Taste in photography tends to be, is perhaps necessarily, global, eclectic, permissive, which means that in the end it must deny the difference between good taste and bad taste. This is what makes all the attempts of photography polemicists to erect a canon seem ingenuous or ignorant. For there is something fake about all photographic controversies—and the attentions of the museum have played a crucial role in making this clear. The museum levels up all schools of photography. Indeed, it makes little sense even to speak of schools. In the history of painting, movements have a genuine life and function: painters are often much better understood in terms of the school or movement to which they belonged. But movements in the history of photography are fleeting, adventitious, sometimes merely perfunctory, and no first-rate photographer is better understood as a member of a group. (Think of Stieglitz and Photo-Secession, Weston and $f64$, Renger-Patzsch and the New Objectivity, Walker Evans and the Farm Security Administration project, Cartier-Bresson and Magnum.) To

group photographers in schools or movements seems to be a kind of misunderstanding, based (once again) on the irrepressible but invariably misleading analogy between photography and painting.

The leading role now played by museums in forming and clarifying the nature of photographic taste seems to mark a new stage from which photography cannot turn back. Accompanying its tendentious respect for the profoundly banal is the museum's diffusion of a historicist view, one that inexorably promotes the entire history of photography. Small wonder that photography critics and photographers seem anxious. Underlying many of the recent defenses of photography is the fear that photography is already a senile art, littered by spurious or dead movements; that the only task left is curatorship and historiography. (While prices skyrocket for photographs old and new.) It is not surprising that this demoralization should be felt at the moment of photography's greatest acceptance, for the true extent of photography's triumph as art, and over art, has not really been understood.

PHOTOGRAPHY ENTERED THE SCENE as an upstart activity, which seemed to encroach on and diminish an accredited art: painting. For Baudelaire, photography was painting's "mortal enemy"; but eventually a truce was worked out, according to which photography was held to be painting's liberator. Weston employed the most common formula for easing the defensiveness of painters when he wrote in 1930:

"Photography has, or will eventually, negate much painting—for which the painter should be deeply grateful." Freed by photography from the drudgery of faithful representation, painting could pursue a higher task: abstraction.* Indeed, the

*Valéry claimed that photography performed the same service for writing, by exposing the "illusory" claim of language to "convey the idea of a visual object with any degree of precision." But writers should not fear that photography "might ultimately restrict the importance of the art of writing and act as its substitute," Valéry says in "The Centenary of Photography" (1929). If photography "discourages us from describing," he argues,

we are thus reminded of the limits of language and are advised, as writers, to put our tools to a use more befitting their true nature. A literature would purify itself if it left to other modes of expression and production the tasks which they can perform far more effectively, and devoted itself to ends it alone can accomplish . . . one of which [is] the perfecting of language that constructs or expounds abstract thought, the other exploring all the variety of poetic patterns and resonances.

Valéry's argument is not convincing. Although a photograph may be said to record or show or present, it does not ever, properly speaking, "describe"; only language describes, which is an event in time. Valéry suggests opening a passport as "proof" of his argument: "the description scrawled there does not bear comparison with the snapshot stapled alongside it." But this is using description in the most debased, impoverished sense; there are passages in Dickens or Nabokov which describe a face or a part of the body better than any photograph. Nor does it argue for the inferior descriptive powers of literature to say, as Valéry does, that "the writer who depicts a landscape or a face, no matter how skillful he may be at his craft, will suggest as many different visions as he has readers." The same is true of a photograph.

most persistent idea in histories of photography and in photography criticism is this mythic pact concluded between painting and photography, which authorized both to pursue their separate but equally valid tasks, while creatively influencing each other. In fact, the legend falsifies much of the history of both painting and photography. The camera's way of fixing the appearance of the external world suggested new patterns of pictorial composition and new subjects to painters: creating a preference for the fragment, raising interest in glimpses of humble life, and in studies of fleeting motion and the effects of light. Painting did not so much turn to abstraction as adopt the camera's eye, becoming (to borrow Mario Praz's words) telescopic, microscopic, and photoscopic in structure. But painters have never stopped attempting to imitate the realistic effects of photography. And, far from confining itself to realistic representation and leaving abstraction to painters, photography has kept up with and absorbed all the anti-naturalistic conquests of painting.

More generally, this legend does not take into account the voraciousness of the photographic enterprise. In the transactions between painting and photography, photography has

As the still photograph is thought to have freed writers from the obligation of describing, movies are often held to have usurped the novelist's task of narrating or storytelling—thereby, some claim, freeing the novel for other, less realistic tasks. This version of the argument is more plausible, because movies are a temporal art. But it does not do justice to the relation between novels and films.

always had the upper hand. There is nothing surprising in the fact that painters from Delacroix and Turner to Picasso and Bacon have used photographs as visual aids, but no one expects photographers to get help from painting. Photographs may be incorporated or transcribed into the painting (or collage, or combine), but photography encapsulates art itself. The experience of looking at paintings may help us to look better at photographs. But photography has weakened our experience of painting. (In more than one sense, Baudelaire was right.) Nobody ever found a lithograph or an engraving of a painting—the popular older methods of mechanical reproduction—more satisfying or more exciting than the painting. But photographs, which turn interesting details into autonomous compositions, which transform true colors into brilliant colors, provide new, irresistible satisfactions. The destiny of photography has taken it far beyond the role to which it was originally thought to be limited: to give more accurate reports on reality (including works of art). Photography is the reality; the real object is often experienced as a letdown. Photographs make normative an experience of art that is mediated, second-hand, intense in a different way. (To deplore that photographs of paintings have become substitutes for the paintings for many people is not to support any mystique of "the original" that addresses the viewer without mediation. Seeing is a complex act, and no great painting communicates its value and quality without some form of preparation and instruction. Moreover, the people who have

a harder time seeing the original work of art after seeing the photographic copy are generally those who would have seen very little in the original.)

As most works of art (including photographs) are now known from photographic copies, photography—and the art activities derived from the model of photography, and the mode of taste derived from photographic taste—has decisively transformed the traditional fine arts and the traditional norms of taste, including the very idea of the work of art. Less and less does the work of art depend on being a unique object, an original made by an individual artist. Much of painting today aspires to the qualities of reproducible objects. Finally, photographs have become so much the leading visual experience that we now have works of art which are produced in order to be photographed. In much of conceptual art, in Christo's packaging of the landscape, in the earthworks of Walter De Maria and Robert Smithson, the artist's work is known principally by the photographic report of it in galleries and museums; sometimes the size is such that it can *only* be known in a photograph (or from an airplane). The photograph is not, even ostensibly, meant to lead us back to an original experience.

It was on the basis of this presumed truce between photography and painting that photography was—grudgingly at first, then enthusiastically—acknowledged as a fine art. But the very question of whether photography is or is not an art is essentially a misleading one. Although photography generates works

that can be called art—it requires subjectivity, it can lie, it gives aesthetic pleasure—photography is not, to begin with, an art form at all. Like language, it is a medium in which works of art (among other things) are made. Out of language, one can make scientific discourse, bureaucratic memoranda, love letters, grocery lists, and Balzac's Paris. Out of photography, one can make passport pictures, weather photographs, pornographic pictures, X-rays, wedding pictures, and Atget's Paris. Photography is not an art like, say, painting and poetry. Although the activities of some photographers conform to the traditional notion of a fine art, the activity of exceptionally talented individuals producing discrete objects that have value in themselves, from the beginning photography has also lent itself to that notion of art which says that art is obsolete. The power of photography—and its centrality in present aesthetic concerns—is that it confirms both ideas of art. But the way in which photography renders art obsolete is, in the long run, stronger.

Painting and photography are not two potentially competitive systems for producing and reproducing images, which simply had to arrive at a proper division of territory to be reconciled. Photography is an enterprise of another order. Photography, though not an art form in itself, has the peculiar capacity to turn all its subjects into works of art. Superseding the issue of whether photography is or is not an art is the fact that photography heralds (and creates) new ambitions for the arts. It is the prototype of the characteristic direction taken in our time by both the modernist high arts

and the commercial arts: the transformation of arts into meta-arts or media. (Such developments as film, TV, video, the tape-based music of Cage, Stockhausen, and Steve Reich are logical extensions of the model established by photography.) The traditional fine arts are elitist: their characteristic form is a single work, produced by an individual; they imply a hierarchy of subject matter in which some subjects are considered important, profound, noble, and others unimportant, trivial, base. The media are democratic: they weaken the role of the specialized producer or *auteur* (by using procedures based on chance, or mechanical techniques which anyone can learn; and by being corporate or collaborative efforts); they regard the whole world as material. The traditional fine arts rely on the distinction between authentic and fake, between original and copy, between good taste and bad taste; the media blur, if they do not abolish outright, these distinctions. The fine arts assume that certain experiences or subjects have a meaning. The media are essentially contentless (this is the truth behind Marshall McLuhan's celebrated remark about the message being the medium itself); their characteristic tone is ironic, or dead-pan, or parodistic. It is inevitable that more and more art will be designed to end as photographs. A modernist would have to rewrite Pater's dictum that all art aspires to the condition of music. Now all art aspires to the condition of photography.

The Image-World

Reality has always been interpreted through the reports given by images; and philosophers since Plato have tried to loosen our dependence on images by evoking the standard of an image-free way of apprehending the real. But when, in the mid-nineteenth century, the standard finally seemed attainable, the retreat of old religious and political illusions before the advance of humanistic and scientific thinking did not—as anticipated—create mass defections to the real. On the contrary, the new age of unbelief strengthened the allegiance to images. The credence that could no longer be given to realities understood *in the form of* images was now being given to realities understood *to be* images, illusions. In the preface to the second edition (1843) of *The Essence of Christianity*, Feuerbach observes about "our era" that it "prefers the image to the thing, the copy to the original, the representation to the reality, appearance to being"—while being aware of doing just that. And his premonitory complaint has been transformed in the twentieth century into a widely agreed-on diagnosis: that a society becomes "modern" when one of its chief activities is producing and consuming images, when images that have extraordinary powers to determine

our demands upon reality and are themselves coveted substitutes for firsthand experience become indispensable to the health of the economy, the stability of the polity, and the pursuit of private happiness.

Feuerbach's words—he is writing a few years after the invention of the camera—seem, more specifically, a presentiment of the impact of photography. For the images that have virtually unlimited authority in a modern society are mainly photographic images; and the scope of that authority stems from the properties peculiar to images taken by cameras.

Such images are indeed able to usurp reality because first of all a photograph is not only an image (as a painting is an image), an interpretation of the real; it is also a trace, something directly stenciled off the real, like a footprint or a death mask. While a painting, even one that meets photographic standards of resemblance, is never more than the stating of an interpretation, a photograph is never less than the registering of an emanation (light waves reflected by objects)—a material vestige of its subject in a way that no painting can be. Between two fantasy alternatives, that Holbein the Younger had lived long enough to have painted Shakespeare or that a prototype of the camera had been invented early enough to have photographed him, most Bardolators would choose the photograph. This is not just because it would presumably show what Shakespeare really looked like, for even if the hypothetical photograph were faded, barely legible, a brownish shadow, we would probably still prefer it to another

glorious Holbein. Having a photograph of Shakespeare would be like having a nail from the True Cross.

Most contemporary expressions of concern that an image-world is replacing the real one continue to echo, as Feuerbach did, the Platonic depreciation of the image: true insofar as it resembles something real, sham because it is no more than a resemblance. But this venerable naïve realism is somewhat beside the point in the era of photographic images, for its blunt contrast between the image ("copy") and the thing depicted (the "original")—which Plato repeatedly illustrates with the example of a painting—does not fit a photograph in so simple a way. Neither does the contrast help in understanding image-making at its origins, when it was a practical, magical activity, a means of appropriating or gaining power over something. The further back we go in history, as E. H. Gombrich has observed, the less sharp is the distinction between images and real things; in primitive societies, the thing and its image were simply two different, that is, physically distinct, manifestations of the same energy or spirit. Hence, the supposed efficacy of images in propitiating and gaining control over powerful presences. Those powers, those presences were present in *them*.

For defenders of the real from Plato to Feuerbach to equate image with mere appearance—that is, to presume that the image is absolutely distinct from the object depicted—is part of that process of desacralization which separates us irrevocably from the world of sacred times and places in which an

image was taken to participate in the reality of the object depicted. What defines the originality of photography is that, at the very moment in the long, increasingly secular history of painting when secularism is entirely triumphant, it revives—in wholly secular terms—something like the primitive status of images. Our irrepressible feeling that the photographic process is something magical has a genuine basis. No one takes an easel painting to be in any sense cosubstantial with its subject; it only represents or refers. But a photograph is not only like its subject, a homage to the subject. It is part of, an extension of that subject; and a potent means of acquiring it, of gaining control over it.

Photography is acquisition in several forms. In its simplest form, we have in a photograph surrogate possession of a cherished person or thing, a possession which gives photographs some of the character of unique objects. Through photographs, we also have a consumer's relation to events, both to events which are part of our experience and to those which are not—a distinction between types of experience that such habit-forming consumership blurs. A third form of acquisition is that, through image-making and image-duplicating machines, we can acquire something as information (rather than experience). Indeed, the importance of photographic images as the medium through which more and more events enter our experience is, finally, only a by-product of their effectiveness in furnishing knowledge dissociated from and independent of experience.

This is the most inclusive form of photographic acquisition. Through being photographed, something becomes part of a system of information, fitted into schemes of classification and storage which range from the crudely chronological order of snapshot sequences pasted in family albums to the dogged accumulations and meticulous filing needed for photography's uses in weather forecasting, astronomy, microbiology, geology, police work, medical training and diagnosis, military reconnaissance, and art history. Photographs do more than redefine the stuff of ordinary experience (people, things, events, whatever we see—albeit differently, often inattentively—with natural vision) and add vast amounts of material that we never see at all. Reality as such is redefined— as an item for exhibition, as a record for scrutiny, as a target for surveillance. The photographic exploration and duplication of the world fragments continuities and feeds the pieces into an interminable dossier, thereby providing possibilities of control that could not even be dreamed of under the earlier system of recording information: writing.

That photographic recording is always, potentially, a means of control was already recognized when such powers were in their infancy. In 1850, Delacroix noted in his *Journal* the success of some "experiments in photography" being made at Cambridge, where astronomers were photographing the sun and the moon and had managed to obtain a pinhead-size impression of the star Vega. He added the following "curious" observation:

Since the light of the star which was daguerreotyped took twenty years to traverse the space separating it from the earth, the ray which was fixed on the plate had consequently left the celestial sphere a long time before Daguerre had discovered the process by means of which we have just gained control of this light.

Leaving behind such puny notions of control as Delacroix's, photography's progress has made ever more literal the senses in which a photograph gives control over the thing photographed. The technology that has already minimized the extent to which the distance separating photographer from subject affects the precision and magnitude of the image; provided ways to photograph things which are unimaginably small as well as those, like stars, which are unimaginably far; rendered picture-taking independent of light itself (infrared photography) and freed the picture-object from its confinement to two dimensions (holography); shrunk the interval between sighting the picture and holding it in one's hands (from the first Kodak, when it took weeks for a developed roll of film to be returned to the amateur photographer, to the Polaroid, which ejects the image in a few seconds); not only got images to move (cinema) but achieved their simultaneous recording and transmission (video)—this technology has made photography an incomparable tool for deciphering behavior, predicting it, and interfering with it.

Photography has powers that no other image-system has ever enjoyed because, unlike the earlier ones, it is *not*

dependent on an image maker. However carefully the photographer intervenes in setting up and guiding the image-making process, the process itself remains an optical-chemical (or electronic) one, the workings of which are automatic, the machinery for which will inevitably be modified to provide still more detailed and, therefore, more useful maps of the real. The mechanical genesis of these images, and the literalness of the powers they confer, amounts to a new relationship between image and reality. And if photography could also be said to restore the most primitive relationship—the partial identity of image and object—the potency of the image is now experienced in a very different way. The primitive notion of the efficacy of images presumes that images possess the qualities of real things, but our inclination is to attribute to real things the qualities of an image.

As everyone knows, primitive people fear that the camera will rob them of some part of their being. In the memoir he published in 1900, at the end of a very long life, Nadar reports that Balzac had a similar "vague dread" of being photographed. His explanation, according to Nadar, was that

every body in its natural state was made up of a series of ghostly images superimposed in layers to infinity, wrapped in infinitesimal films . . . Man never having been able to create, that is to make something material from an apparition, from something impalpable, or to make from nothing, an object—each Daguerreian

operation was therefore going to lay hold of, detach, and use up one of the layers of the body on which it focused.

It seems fitting for Balzac to have had this particular brand of trepidation—"Was Balzac's fear of the Daguerreotype real or feigned?" Nadar asks. "It was real . . . "—since the procedure of photography is a materializing, so to speak, of what is most original in his procedure as a novelist. The Balzacian operation was to magnify tiny details, as in a photographic enlargement, to juxtapose incongruous traits or items, as in a photographic layout: made expressive in this way, any one thing can be connected with everything else. For Balzac, the spirit of an entire milieu could be disclosed by a single material detail, however paltry or arbitrary-seeming. The whole of a life may be summed up in a momentary appearance.* And

*I am drawing on the account of Balzac's realism in Erich Auerbach's *Mimesis*. The passage that Auerbach describes from the beginning of *Le Père Goriot* (1834)—Balzac is describing the dining room of the Vauquer pension at seven in the morning and the entry of Madame Vauquer—could hardly be more explicit (or proto-Proustian). "Her whole person," Balzac writes, "explains the pension, as the pension implies her person . . . The short-statured woman's blowsy *embonpoint* is the product of the life here, as typhoid is the consequence of the exhalations of a hospital. Her knitted wool petticoat, which is longer than her outer skirt (made of an old dress), and whose wadding is escaping by the gaps in the splitting material, sums up the drawing-room, the dining room, the little garden, announces the cooking and gives an inkling of the boarders. When she is there, the spectacle is complete."

a change in appearances is a change in the person, for he refused to posit any "real" person ensconced behind these appearances. Balzac's fanciful theory, expressed to Nadar, that a body is composed of an infinite series of "ghostly images," eerily parallels the supposedly realistic theory expressed in his novels, that a person is an aggregate of appearances, appearances which can be made to yield, by proper focusing, infinite layers of significance. To view reality as an endless set of situations which mirror each other, to extract analogies from the most dissimilar things, is to anticipate the characteristic form of perception stimulated by photographic images. Reality itself has started to be understood as a kind of writing, which has to be decoded—even as photographed images were themselves first compared to writing. (Niépce's name for the process whereby the image appears on the plate was heliography, sun-writing; Fox Talbot called the camera "the pencil of nature.")

The problem with Feuerbach's contrast of "original" with "copy" is its static definitions of reality and image. It assumes that what is real persists, unchanged and intact, while only images have changed: shored up by the most tenuous claims to credibility, they have somehow become more seductive. But the notions of image and reality are complementary. When the notion of reality changes, so does that of the image, and vice versa. "Our era" does not prefer images to real things out of perversity but partly in response to the ways in which the notion of what is real has been progressively complicated

and weakened, one of the early ways being the criticism of reality as façade which arose among the enlightened middle classes in the last century. (This was of course the very opposite of the effect intended.) To reduce large parts of what has hitherto been regarded as real to mere fantasy, as Feuerbach did when he called religion "the dream of the human mind" and dismissed theological ideas as psychological projections; or to inflate the random and trivial details of everyday life into ciphers of hidden historical and psychological forces, as Balzac did in his encyclopedia of social reality in novel form— these are themselves ways of experiencing reality as a set of appearances, an image.

Few people in this society share the primitive dread of cameras that comes from thinking of the photograph as a material part of themselves. But some trace of the magic remains: for example, in our reluctance to tear up or throw away the photograph of a loved one, especially of someone dead or far away. To do so is a ruthless gesture of rejection. In *Jude the Obscure* it is Jude's discovery that Arabella has sold the maple frame with the photograph of himself in it which he gave her on their wedding day that signifies to Jude "the utter death of every sentiment in his wife" and is "the conclusive little stroke to demolish all sentiment in him." But the true modern primitivism is not to regard the image as a real thing; photographic images are hardly that real. Instead, reality has come to seem more and more like what we are shown by cameras. It is common now for people to insist about their

experience of a violent event in which they were caught up—
a plane crash, a shoot-out, a terrorist bombing—that "it
seemed like a movie." This is said, other descriptions seeming
insufficient, in order to explain how real it was. While many
people in non-industrialized countries still feel apprehensive
when being photographed, divining it to be some kind of tres-
pass, an act of disrespect, a sublimated looting of the
personality or the culture, people in industrialized countries
seek to have their photographs taken—feel that they are
images, and are made real by photographs.

A STEADILY MORE COMPLEX sense of the real creates its own
compensatory fervors and simplifications, the most addictive
of which is picture-taking. It is as if photographers, respond-
ing to an increasingly depleted sense of reality, were looking
for a transfusion—traveling to new experiences, refreshing
the old ones. Their ubiquitous activities amount to the most
radical, and the safest, version of mobility. The urge to have
new experiences is translated into the urge to take photo-
graphs: experience seeking a crisis-proof form.

As the taking of photographs seems almost obligatory to
those who travel about, the passionate collecting of them has
special appeal for those confined—either by choice, incap-
acity, or coercion—to indoor space. Photograph collections
can be used to make a substitute world, keyed to exalting or
consoling or tantalizing images. A photograph can be the
starting point of a romance (Hardy's Jude had already fallen

in love with Sue Bridehead's photograph before he met her), but it is more common for the erotic relation to be not only created by but understood as limited to the photographs. In Cocteau's *Les Enfants Terribles*, the narcissistic brother and sister share their bedroom, their "secret room," with images of boxers, movie stars, and murderers. Isolating themselves in their lair to live out their private legend, the two adolescents put up these photographs, a private pantheon. On one wall of cell No. 426 in Fresnes Prison in the early 1940s Jean Genet pasted the photographs of twenty criminals he had clipped from newspapers, twenty faces in which he discerned "the sacred sign of the monster," and in their honor wrote *Our Lady of the Flowers*; they served as his muses, his models, his erotic talismans. "They watch over my little routines," writes Genet—conflating reverie, masturbation, and writing—and "are all the family I have and my only friends." For stay-at-homes, prisoners, and the self-imprisoned, to live among the photographs of glamorous strangers is a sentimental response to isolation and an insolent challenge to it.

J. G. Ballard's novel *Crash* (1973) describes a more specialized collecting of photographs in the service of sexual obsession: photographs of car accidents which the narrator's friend Vaughan collects while preparing to stage his own death in a car crash. The acting out of his erotic vision of car death is anticipated and the fantasy itself further eroticized by the repeated perusal of these photographs. At one end of the spectrum, photographs are objective data; at the other end,

they are items of psychological science fiction. And as in even the most dreadful, or neutral-seeming, reality a sexual imperative can be found, so even the most banal photograph-document can mutate into an emblem of desire. The mug shot is a clue to a detective, an erotic fetish to a fellow thief. To Hofrat Behrens, in *The Magic Mountain*, the pulmonary X-rays of his patients are diagnostic tools. To Hans Castorp, serving an indefinite sentence in Behrens's TB sanatorium, and made lovesick by the enigmatic, unattainable Clavdia Chauchat, "Clavdia's X-ray portrait, showing not her face, but the delicate bony structure of the upper half of her body, and the organs of the thoracic cavity, surrounded by the pale, ghostlike envelope of flesh," is the most precious of trophies. The "transparent portrait" is a far more intimate vestige of his beloved than the Hofrat's painting of Clavdia, that "exterior portrait," which Hans had once gazed at with such longing.

Photographs are a way of imprisoning reality, understood as recalcitrant, inaccessible; of making it stand still. Or they enlarge a reality that is felt to be shrunk, hollowed out, perishable, remote. One can't possess reality, one can possess (and be possessed by) images—as, according to Proust, most ambitious of voluntary prisoners, one can't possess the present but one can possess the past. Nothing could be more unlike the self-sacrificial travail of an artist like Proust than the effortlessness of picture-taking, which must be the sole activity resulting in accredited works of art in which a single

movement, a touch of the finger, produces a complete work. While the Proustian labors presuppose that reality is distant, photography implies instant access to the real. But the results of this practice of instant access are another way of creating distance. To possess the world in the form of images is, precisely, to reexperience the unreality and remoteness of the real.

The strategy of Proust's realism presumes distance from what is normally experienced as real, the present, in order to reanimate what is usually available only in a remote and shadowy form, the past—which is where the present becomes in his sense real, that is, something that can be possessed. In this effort photographs were of no help. Whenever Proust mentions photographs, he does so disparagingly: as a synonym for a shallow, too exclusively visual, merely voluntary relation to the past, whose yield is insignificant compared with the deep discoveries to be made by responding to cues given by all the senses—the technique he called "involuntary memory." One can't imagine the Overture to *Swann's Way* ending with the narrator's coming across a snapshot of the parish church at Combray and the savoring of *that* visual crumb, instead of the taste of the humble madeleine dipped in tea, making an entire part of his past spring into view. But this is not because a photograph cannot evoke memories (it can, depending on the quality of the viewer rather than of the photograph) but because of what Proust makes clear about his own demands upon imaginative recall, that it be not just

extensive and accurate but give the texture and essence of things. And by considering photographs only so far as he could use them, as an instrument of memory, Proust somewhat misconstrues what photographs are: not so much an instrument of memory as an invention of it or a replacement.

It is not reality that photographs make immediately accessible, but images. For example, now all adults can know exactly how they and their parents and grandparents looked as children—a knowledge not available to anyone before the invention of cameras, not even to that tiny minority among whom it was customary to commission paintings of their children. Most of these portraits were less informative than any snapshot. And even the very wealthy usually owned just one portrait of themselves or any of their forebears as children, that is, an image of one moment of childhood, whereas it is common to have many photographs of oneself, the camera offering the possibility of possessing a complete record, at all ages. The point of the standard portraits in the bourgeois household of the eighteenth and nineteenth centuries was to confirm an ideal of the sitter (proclaiming social standing, embellishing personal appearance); given this purpose, it is clear why their owners did not feel the need to have more than one. What the photograph-record confirms is, more modestly, simply that the subject exists; therefore, one can never have too many.

The fear that a subject's uniqueness was leveled by being photographed was never so frequently expressed as in the

1850s, the years when portrait photography gave the first example of how cameras could create instant fashions and durable industries. In Melville's *Pierre*, published at the start of the decade, the hero, another fevered champion of voluntary isolation,

considered with what infinite readiness now, the most faithful portrait of any one could be taken by the Daguerreotype, whereas in former times a faithful portrait was only within the power of the moneyed, or mental aristocrats of the earth. How natural then the inference, that instead of, as in old times, immortalizing a genius, a portrait now only *dayalized* a dunce. Besides, when every body has his portrait published, true distinction lies in not having yours published at all.

But if photographs demean, paintings distort in the opposite way: they make grandiose. Melville's intuition is that all forms of portraiture in the business civilization are compromised; at least, so it appears to Pierre, a paragon of alienated sensibility. Just as a photograph is too little in a mass society, a painting is too much. The nature of a painting, Pierre observes, makes it

better entitled to reverence than the man; inasmuch as nothing belittling can be imagined concerning the portrait, whereas many unavoidably belittling things can be fancied as touching the man.

179

Even if such ironies can be considered to have been dissolved by the completeness of photography's triumph, the main difference between a painting and a photograph in the matter of portraiture still holds. Paintings invariably sum up; photographs usually do not. Photographic images are pieces of evidence in an ongoing biography or history. And one photograph, unlike one painting, implies that there will be others.

"Ever—the Human Document to keep the present and the future in touch with the past," said Lewis Hine. But what photography supplies is not only a record of the past but a new way of dealing with the present, as the effects of the countless billions of contemporary photograph-documents attest. While old photographs fill out our mental image of the past, the photographs being taken now transform what is present into a mental image, like the past. Cameras establish an inferential relation to the present (reality is known by its traces), provide an instantly retroactive view of experience. Photographs give mock forms of possession: of the past, the present, even the future. In Nabokov's *Invitation to a Beheading* (1938), the prisoner Cincinnatus is shown the "photo-horoscope" of a child cast by the sinister M'sieur Pierre: an album of photographs of little Emmie as an infant, then a small child, then pre-pubescent, as she is now, then—by retouching and using photographs of her mother—of Emmie the adolescent, the bride, the thirty-year-old, concluding with a photograph at age forty, Emmie on her deathbed. A "parody

of the work of time" is what Nabokov calls this exemplary artifact; it is also a parody of the work of photography.

PHOTOGRAPHY, WHICH HAS SO many narcissistic uses, is also a powerful instrument for depersonalizing our relation to the world; and the two uses are complementary. Like a pair of binoculars with no right or wrong end, the camera makes exotic things near, intimate; and familiar things small, abstract, strange, much farther away. It offers, in one easy, habit-forming activity, both participation and alienation in our own lives and those of others—allowing us to participate, while confirming alienation. War and photography now seem inseparable, and plane crashes and other horrific accidents always attract people with cameras. A society which makes it normative to aspire never to experience privation, failure, misery, pain, dread disease, and in which death itself is regarded not as natural and inevitable but as a cruel, unmerited disaster, creates a tremendous curiosity about these events—a curiosity that is partly satisfied through picture-taking. The feeling of being exempt from calamity stimulates interest in looking at painful pictures, and looking at them suggests and strengthens the feeling that one is exempt. Partly it is because one is "here," not "there," and partly it is the character of inevitability that all events acquire when they are transmuted into images. In the real world, something *is* happening and no one knows what is *going* to happen.

In the image-world, it *has* happened, and it *will* forever happen in that way.

Knowing a great deal about what is in the world (art, catastrophe, the beauties of nature) through photographic images, people are frequently disappointed, surprised, unmoved when they see the real thing. For photographic images tend to subtract feeling from something we experience at first hand and the feelings they do arouse are, largely, not those we have in real life. Often something disturbs us more in photographed form than it does when we actually experience it. In a hospital in Shanghai in 1973, watching a factory worker with advanced ulcers have nine-tenths of his stomach removed under acupuncture anesthesia, I managed to follow the three-hour procedure (the first operation I'd ever observed) without queasiness, never once feeling the need to look away. In a movie theater in Paris a year later, the less gory operation in Antonioni's China documentary *Chung Kuo* made me flinch at the first cut of the scalpel and avert my eyes several times during the sequence. One is vulnerable to disturbing events in the form of photographic images in a way that one is not to the real thing. That vulnerability is part of the distinctive passivity of someone who is a spectator twice over, spectator of events already shaped, first by the participants and second by the image maker. For the real operation I had to get scrubbed, don a surgical gown, then stand alongside the busy surgeons and nurses with my roles to play: inhibited adult, well-mannered guest, respectful witness.

The movie operation precludes not only this modest participation but whatever is active in spectatorship. In the operating room, I am the one who changes focus, who makes the close-ups and the medium shots. In the theater, Antonioni has already chosen what parts of the operation I can watch; the camera looks for me—and obliges me to look, leaving as my only option not to look. Further, the movie condenses something that takes hours to a few minutes, leaving only interesting parts presented in an interesting way, that is, with the intent to stir or shock. The dramatic is dramatized, by the didactics of layout and montage. We turn the page in a photo-magazine, a new sequence starts in a movie, making a contrast that is sharper than the contrast between successive events in real time.

Nothing could be more instructive about the meaning of photography for us—as, among other things, a method of hyping up the real—than the attacks on Antonioni's film in the Chinese press in early 1974. They make a negative catalogue of all the devices of modern photography, still and film.* While for us photography is intimately connected with

*See *A Vicious Motive, Despicable Tricks—A Criticism of Antonioni's Anti-China Film "China"* (Peking: Foreign Languages Press, 1974), an eighteen-page pamphlet (unsigned) which reproduces an article that appeared in the paper *Renminh Ribao* on January 30, 1974; and "Repudiating Antonioni's Anti-China Film," *Peking Review*, No. 8 (February 22, 1974), which supplies abridged versions of three other articles published that month. The aim of these articles is not, of course, to expound a view of

discontinuous ways of seeing (the point is precisely to see the whole by means of a part—an arresting detail, a striking way of cropping), in China it is connected only with continuity. Not only are there proper subjects for the camera, those which are positive, inspirational (exemplary activities, smiling people, bright weather), and orderly, but there are proper ways of photographing, which derive from notions about the moral order of space that preclude the very idea of photographic seeing. Thus Antonioni was reproached for photographing things that were old, or old-fashioned—"he sought out and took dilapidated walls and blackboard newspapers discarded long ago"; paying "no attention to big and small tractors working in the fields, [he] chose only a donkey pulling a stone roller"—and for showing undecorous moments—"he disgustingly filmed people blowing their noses and going to the latrine"—and undisciplined movement—"instead of taking shots of pupils in the classroom in our factory-run primary school, he filmed the children running out of the classroom after a class." And he was accused of

photography—their interest on that score is inadvertent—but to construct a model ideological enemy, as in other mass educational campaigns staged during this period. Given this purpose, it was as unnecessary for the tens of millions mobilized in meetings held in schools, factories, army units, and communes around the country to "Criticize Antonioni's Anti-China Film" to have actually seen *Chung Kuo* as it was for the participants in the "Criticize Lin Piao and Confucius" campaign of 1976 to have read a text of Confucius.

denigrating the right subjects by his way of photographing them: by using "dim and dreary colors" and hiding people in "dark shadows"; by treating the same subject with a variety of shots—"there are sometimes long-shots, sometimes close-ups, sometimes from the front, and sometimes from behind"—that is, for not showing things from the point of view of a single, ideally placed observer; by using high and low angles—"The camera was intentionally turned on this magnificent modern bridge from very bad angles in order to make it appear crooked and tottering"; and by not taking enough full shots—"He racked his brain to get such close-ups in an attempt to distort the people's image and uglify their spiritual outlook."

Besides the mass-produced photographic iconography of revered leaders, revolutionary kitsch, and cultural treasures, one often sees photographs of a private sort in China. Many people possess pictures of their loved ones, tacked to the wall or stuck under the glass on top of the dresser or office desk. A large number of these are the sort of snapshots taken here at family gatherings and on trips; but none is a candid photograph, not even of the kind that the most unsophisticated camera user in this society finds normal—a baby crawling on the floor, someone in mid-gesture. Sports photographs show the team as a group, or only the most stylized balletic moments of play: generally, what people do with the camera is assemble for it, then line up in a row or two. There is no interest in catching a subject in movement. This is, one

supposes, partly because of certain old conventions of decorum in conduct and imagery. And it is the characteristic visual taste of those at the first stage of camera culture, when the image is defined as something that can be stolen from its owner; thus, Antonioni was reproached for "forcibly taking shots against people's wishes," like "a thief." Possession of a camera does not license intrusion, as it does in this society whether people like it or not. (The good manners of a camera culture dictate that one is supposed to pretend not to notice when one is being photographed by a stranger in a public place as long as the photographer stays at a discreet distance— that is, one is supposed neither to forbid the picture-taking nor to start posing.) Unlike here, where we pose where we can and yield when we must, in China taking pictures is always a ritual; it always involves posing and, necessarily, consent. Someone who "deliberately stalked people who were unaware of his intention to film them" was depriving people and things of their right to pose, in order to look their best.

Antonioni devoted nearly all of the sequence in *Chung Kuo* about Peking's Tien An Men Square, the country's foremost goal of political pilgrimage, to the pilgrims waiting to be photographed. The interest to Antonioni of showing Chinese performing that elementary rite, having a trip documented by the camera, is evident: the photograph and being photographed are favorite contemporary subjects for the camera. To his critics, the desire of visitors to Tien An Men Square for a photograph souvenir.

is a reflection of their deep revolutionary feelings. But with bad intentions, Antonioni, instead of showing this reality, took shots only of people's clothing, movement, and expressions: here, someone's ruffled hair; there, people peering, their eyes dazzled by the sun; one moment, their sleeves; another, their trousers . . .

The Chinese resist the photographic dismemberment of reality. Close-ups are not used. Even the postcards of antiquities and works of art sold in museums do not show part of something; the object is always photographed straight on, centered, evenly lit, and in its entirety.

We find the Chinese naïve for not perceiving the beauty of the cracked peeling door, the picturesqueness of disorder, the force of the odd angle and the significant detail, the poetry of the turned back. We have a modern notion of embellishment— beauty is not inherent in anything; it is to be found, by another way of seeing—as well as a wider notion of meaning, which photography's many uses illustrate and powerfully reinforce. The more numerous the variations of something, the richer its possibilities of meaning: thus, more is said with photographs in the West than in China today. Apart from whatever is true about *Chung Kuo* as an item of ideological merchandise (and the Chinese are not wrong in finding the film condescending), Antonioni's images simply mean *more* than any images the Chinese release of themselves. The Chinese don't want photographs to mean very much or to be very interesting. They do not want to see the world from an unusual

angle, to discover new subjects. Photographs are supposed to display what has already been described. Photography for us is a double-edged instrument for producing clichés (the French word that means both trite expression and photographic negative) and for serving up "fresh" views. For the Chinese authorities, there are only clichés—which they consider not to be clichés but "correct" views.

In China today, only two realities are acknowledged. We see reality as hopelessly and interestingly plural. In China, what is defined as an issue for debate is one about which there are "two lines," a right one and a wrong one. Our society proposes a spectrum of discontinuous choices and perceptions. Theirs is constructed around a single, ideal observer; and photographs contribute their bit to the Great Monologue. For us, there are dispersed, interchangeable "points of view"; photography is a polylogue. The current Chinese ideology defines reality as a historical process structured by recurrent dualisms with clearly outlined, morally colored meanings; the past, for the most part, is simply judged as bad. For us, there are historical processes with awesomely complex and sometimes contradictory meanings; and arts which draw much of their value from our consciousness of time as history, like photography. (This is why the passing of time adds to the aesthetic value of photographs, and the scars of time make objects more rather than less enticing to photographers.) With the idea of history, we certify our interest in knowing the greatest number of things. The only use the

Chinese are allowed to make of their history is didactic: their interest in history is narrow, moralistic, deforming, uncurious. Hence, photography in our sense has no place in their society.

The limits placed on photography in China only reflect the character of their society, a society unified by an ideology of stark, unremitting conflict. Our unlimited use of photographic images not only reflects but gives shape to this society, one unified by the denial of conflict. Our very notion of the world—the capitalist twentieth century's "one world"—is like a photographic overview. The world is "one" not because it is united but because a tour of its diverse contents does not reveal conflict but only an even more astounding diversity. This spurious unity of the world is effected by translating its contents into images. Images are always compatible, or can be made compatible, even when the realities they depict are not.

Photography does not simply reproduce the real, it recycles it—a key procedure of a modern society. In the form of photographic images, things and events are put to new uses, assigned new meanings, which go beyond the distinctions between the beautiful and the ugly, the true and the false, the useful and the useless, good taste and bad. Photography is one of the chief means for producing that quality ascribed to things and situations which erases these distinctions: "the interesting." What makes something interesting is that it can be seen to be like, or analogous to, something else. There is

an art and there are fashions of seeing things in order to make them interesting; and to supply this art, these fashions, there is a steady recycling of the artifacts and tastes of the past. Clichés, recycled, become meta-clichés. The photographic recycling makes clichés out of unique objects, distinctive and vivid artifacts out of clichés. Images of real things are inter-layered with images of images. The Chinese circumscribe the uses of photography so that there are no layers or strata of images, and all images reinforce and reiterate each other.* We make of photography a means by which, precisely, any-thing can be said, any purpose served. What in reality is

*The Chinese concern for the reiterative function of images (and of words) inspires the distributing of additional images, photographs that depict scenes in which, clearly, no photographer could have been present; and the continuing use of such photographs suggests how slender is the popu-lation's understanding of what photographic images and picture-taking imply. In his book *Chinese Shadows*, Simon Leys gives an example from the "Movement to Emulate Lei Feng," a mass campaign of the mid-1960s to inculcate the ideals of Maoist citizenship built around the apotheosis of an Unknown Citizen, a conscript named Lei Feng who died at twenty in a banal accident. Lei Feng Exhibitions organized in the large cities included "photographic documents, such as 'Lei Feng helping an old woman to cross the street,' 'Lei Feng secretly [sic] doing his comrade's washing,' 'Lei Feng giving his lunch to a comrade who forgot his lunch box,' and so forth," with, apparently, nobody questioning "the providen-tial presence of a photographer during the various incidents in the life of that humble, hitherto unknown soldier." In China, what makes an image true is that it is good for people to see it.

discrete, images join. In the form of a photograph the explosion of an A-bomb can be used to advertise a safe.

To US, THE DIFFERENCE between the photographer as an individual eye and the photographer as an objective recorder seems fundamental, the difference often regarded, mistakenly, as separating photography as art from photography as document. But both are logical extensions of what photography means: note-taking on, potentially, everything in the world, from every possible angle. The same Nadar who took the most authoritative celebrity portraits of his time and did the first photo-interviews was also the first photographer to take aerial views; and when he performed "the Daguerreian operation" on Paris from a balloon in 1855 he immediately grasped the future benefit of photography to warmakers.

Two attitudes underlie this presumption that anything in the world is material for the camera. One finds that there is beauty or at least interest in everything, seen with an acute enough eye. (And the aestheticizing of reality that makes everything, anything, available to the camera is what also permits the co-opting of any photograph, even one of an utterly practical sort, as art.) The other treats everything as the object of some present or future use, as matter for estimates, decisions, and predictions. According to one attitude, there is nothing that should not be *seen*; according to the other, there is nothing that should not be *recorded*. Cameras implement an aesthetic view of reality by being a machine-toy that

extends to everyone the possibility of making disinterested judgments about importance, interest, beauty. ("*That* would make a good picture.") Cameras implement the instrumental view of reality by gathering information that enables us to make a more accurate and much quicker response to whatever is going on. The response may of course be either repressive or benevolent: military reconnaissance photographs help snuff out lives, X-rays help save them.

Though these two attitudes, the aesthetic and the instrumental, seem to produce contradictory and even incompatible feelings about people and situations, that is the altogether characteristic contradiction of attitude which members of a society that divorces public from private are expected to share in and live with. And there is perhaps no activity which prepares us so well to live with these contradictory attitudes as does picture-taking, which lends itself so brilliantly to both. On the one hand, cameras arm vision in the service of power—of the state, of industry, of science. On the other hand, cameras make vision expressive in that mythical space known as private life. In China, where no space is left over from politics and moralism for expressions of aesthetic sensibility, only some things are to be photographed and only in certain ways. For us, as we become further detached from politics, there is more and more free space to fill up with exercises of sensibility such as cameras afford. One of the effects of the newer camera technology (video, instant movies) has been to turn even more of what is done with cameras in

private to narcissistic uses—that is, to self-surveillance. But such currently popular uses of image-feedback in the bedroom, the therapy session, and the weekend conference seem far less momentous than video's potential as a tool for surveillance in public places. Presumably, the Chinese will eventually make the same instrumental uses of photography that we do, except, perhaps, this one. Our inclination to treat character as equivalent to behavior makes more acceptable a widespread public installation of the mechanized regard from the outside provided by cameras. China's far more repressive standards of order require not only monitoring behavior but changing hearts; there, surveillance is internalized to a degree without precedent, which suggests a more limited future in their society for the camera as a means of surveillance.

China offers the model of one kind of dictatorship, whose master idea is "the good," in which the most unsparing limits are placed on all forms of expression, including images. The future may offer another kind of dictatorship, whose master idea is "the interesting," in which images of all sorts, stereotyped and eccentric, proliferate. Something like this is suggested in Nabokov's *Invitation to a Beheading*. Its portrait of a model totalitarian state contains only one, omnipresent art: photography—and the friendly photographer who hovers around the hero's death cell turns out, at the end of the novel, to be the headsman. And there seems no way (short of undergoing a vast historical amnesia, as in China) of limiting the proliferation of photographic images. The only question is

whether the function of the image-world created by cameras could be other than it is. The present function is clear enough, if one considers in what contexts photographic images are seen, what dependencies they create, what antagonisms they pacify—that is, what institutions they buttress, whose needs they really serve.

A capitalist society requires a culture based on images. It needs to furnish vast amounts of entertainment in order to stimulate buying and anesthetize the injuries of class, race, and sex. And it needs to gather unlimited amounts of information, the better to exploit natural resources, increase productivity, keep order, make war, give jobs to bureaucrats. The camera's twin capacities, to subjectivize reality and to objectify it, ideally serve these needs and strengthen them. Cameras define reality in the two ways essential to the workings of an advanced industrial society: as a spectacle (for masses) and as an object of surveillance (for rulers). The production of images also furnishes a ruling ideology. Social change is replaced by a change in images. The freedom to consume a plurality of images and goods is equated with freedom itself. The narrowing of free political choice to free economic consumption requires the unlimited production and consumption of images.

THE FINAL REASON FOR the need to photograph everything lies in the very logic of consumption itself. To consume means to burn, to use up—and, therefore, to need to be replenished.

As we make images and consume them, we need still more images; and still more. But images are not a treasure for which the world must be ransacked; they are precisely what is at hand wherever the eye falls. The possession of a camera can inspire something akin to lust. And like all credible forms of lust, it cannot be satisfied: first, because the possibilities of photography are infinite; and, second, because the project is finally self-devouring. The attempts by photographers to bolster up a depleted sense of reality contribute to the depletion. Our oppressive sense of the transience of everything is more acute since cameras gave us the means to "fix" the fleeting moment. We consume images at an ever faster rate and, as Balzac suspected cameras used up layers of the body, images consume reality. Cameras are the antidote and the disease, a means of appropriating reality and a means of making it obsolete.

The powers of photography have in effect de-Platonized our understanding of reality, making it less and less plausible to reflect upon our experience according to the distinction between images and things, between copies and originals. It suited Plato's derogatory attitude toward images to liken them to shadows—transitory, minimally informative, immaterial, impotent co-presences of the real things which cast them. But the force of photographic images comes from their being material realities in their own right, richly informative deposits left in the wake of whatever emitted them, potent means for turning the tables on reality—for turning *it* into a

shadow. Images are more real than anyone could have supposed. And just because they are an unlimited resource, one that cannot be exhausted by consumerist waste, there is all the more reason to apply the conservationist remedy. If there can be a better way for the real world to include the one of images, it will require an ecology not only of real things but of images as well.

A Brief Anthology of Quotations

[HOMAGE TO W. B.]

I longed to arrest all beauty that came before me, and at
length the longing has been satisfied.

—Julia Margaret Cameron

I long to have such a memorial of every being dear to me in
the world. It is not merely the likeness which is precious in
such cases—but the association and the sense of nearness
involved in the thing . . . the fact of the *very shadow of the per-
son* lying there fixed forever! It is the very sanctification of
portraits I think—and it is not at all monstrous in me to say,
what my brothers cry out against so vehemently, that I would
rather have such a memorial of one I dearly loved, than the
noblest artist's work ever produced.

—Elizabeth Barrett
(1843, letter to Mary Russell Mitford)

Your photography is a record of your living, for anyone who
really sees. You may see and be affected by other people's
ways, you may even use them to find your own, but you
will have eventually to free yourself of them. That is what

Nietzsche meant when he said, "I have just read Schopenhauer, now I have to get rid of him." He knew how insidious other people's ways could be, particularly those which have the forcefulness of profound experience, if you let them get between you and your own vision.

—Paul Strand

That the outer man is a picture of the inner, and the face an expression and revelation of the whole character, is a presumption likely enough in itself, and therefore a safe one to go on; borne out as it is by the fact that people are always anxious to see anyone who has made himself famous ... Photography ... offers the most complete satisfaction of our curiosity.

—Schopenhauer

To experience a thing as beautiful means: to experience it necessarily wrongly.

—Nietzsche

Now, for an absurdly small sum, we may become familiar not only with every famous locality in the world, but also with almost every man of note in Europe. The ubiquity of the photographer is something wonderful. All of us have seen the Alps and know Chamonix and the Mer de Glace by heart, though we have never braved the horrors of the Channel ... We have crossed the Andes, ascended Tenerife, entered Japan,

"done" Niagara and the Thousand Isles, drunk delight of battle with our peers (at shop windows), sat at the councils of the mighty, grown familiar with kings, emperors and queens, prima donnas, pets of the ballet, and "well graced actors." Ghosts have we seen and have not trembled; stood before royalty and have not uncovered; and looked, in short, through a three-inch lens at every single pomp and vanity of this wicked but beautiful world.

—"D.P.," columnist in *Once a Week*
[London], June 1, 1861

It has quite justly been said of Atget that he photographed [deserted Paris streets] like scenes of crime. The scene of a crime, too, is deserted; it is photographed for the purpose of establishing evidence. With Atget, photographs become standard evidence for historical occurrences, and acquire a hidden political significance.

—Walter Benjamin

If I could tell the story in words, I wouldn't need to lug a camera.

—Lewis Hine

I went to Marseille. A small allowance enabled me to get along, and I worked with enjoyment. I had just discovered the Leica. It became the extension of my eye, and I have never been separated from it since I found it. I prowled the streets

all day, feeling very strung-up and ready to pounce, determined to "trap" life—to preserve life in the act of living. Above all, I craved to seize the whole essence, in the confines of one single photograph, of some situation that was in the process of unrolling itself before my eyes.

—Henri Cartier-Bresson

It's hard to tell where you leave off and the camera begins.

A Minolta 35mm SLR makes it almost effortless to capture the world around you. Or express the world within you. It feels comfortable in your hands. Your fingers fall into place naturally. Everything works so smoothly that the camera becomes a part of you. You never have to take your eye from the viewfinder to make adjustments. So you can concentrate on creating the picture . . . And you're free to probe the limits of your imagination with a Minolta. More than 40 lenses in the superbly crafted Rokkor-X and Minolta/Celtic systems let you bridge distances or capture a spectacular "fisheye" panorama . . .

MINOLTA
When you are the camera and the camera is you

—advertisement (1976)

I photograph what I do not wish to paint and I paint what I cannot photograph.

—Man Ray

Only with effort can the camera be forced to lie: basically it is an honest medium: so the photographer is much more likely to approach nature in a spirit of inquiry, of communion, instead of with the saucy swagger of self-dubbed "artists." And contemporary vision, the new life, is based on honest approach to all problems, be they morals or art. False fronts to buildings, false standards in morals, subterfuges and mummery of all kinds, must be, will be scrapped.

—Edward Weston

I attempt, through much of my work, to animate all things— even so-called "inanimate" objects—with the spirit of man. I have come, by degrees, to realize that this extremely animistic projection rises, ultimately, from my profound fear and disquiet over the accelerating mechanization of man's life; and the resulting attempts to stamp out individuality in all the spheres of man's activity—this whole process being one of the dominant expressions of our military-industrial society ... The creative photographer sets free the *human contents* of objects; and imparts humanity to the inhuman world around him.

—Clarence John Laughlin

You can photograph anything now.

—Robert Frank

I always prefer to work in the studio. It isolates people from their environment. They become in a sense ... symbolic of

themselves. I often feel that people come to me to be photographed as they would go to a doctor or a fortune teller—to find out how they are. So they're dependent on me. I have to engage them. Otherwise there's nothing to photograph. The concentration has to come from me and involve them. Sometimes the force of it grows so strong that sounds in the studio go unheard. Time stops. We share a brief, intense intimacy. But it's unearned. It has no past . . . no future. And when the sitting is over—when the picture is done—there's nothing left except the photograph . . . the photograph and a kind of embarrassment. They leave . . . and I don't know them. I've hardly heard what they've said. If I meet them a week later in a room somewhere, I expect they won't recognize me. Because I don't feel I was really there. At least the part of me that was . . . is now in the photograph. And the photographs have a reality for me that the people don't. It's through the photographs that I know them. Maybe it's in the nature of being a photographer. I'm never really implicated. I don't have to have any real knowledge. It's all a question of recognitions.

—Richard Avedon

The daguerreotype is not merely an instrument which serves to draw nature . . . [it] gives her the power to reproduce herself.

—Louis Daguerre (1838, from a notice circulated to attract investors)

The creations of man or nature never have more grandeur than in an Ansel Adams photograph, and his image can seize the viewer with more force than the natural object from which it was made.

<div align="right">—advertisement for a book of
photographs by Adams (1974)</div>

**This Polaroid SX-70 photograph is part of
the collection of the Museum of Modern Art.**
The work is by Lucas Samaras, one of America's foremost artists. It is part of one of the world's most important collections. It was produced using the finest instant photographic system in the world, the Polaroid SX-70 Land camera. That same camera is owned by millions. A camera of extraordinary quality and versatility capable of exposures from 10.4 inches to infinity . . . Samaras' work of art from the SX-70, a work of art in itself.

<div align="right">—advertisement (1977)</div>

Most of my photographs are compassionate, gentle, and personal. They tend to let the viewer see himself. They tend not to preach. And they tend not to pose as art.

<div align="right">—Bruce Davidson</div>

New forms in art are created by the canonization of peripheral forms.

<div align="right">—Viktor Shklovsky</div>

. . . a new industry has arisen which contributes not a little to confirming stupidity in its faith and to ruining what might have remained of the divine in the French genius. The idolatrous crowd postulates an ideal worthy of itself and appropriate to its nature—that is perfectly understandable. As far as painting and sculpture are concerned, the current credo of the sophisticated public, above all in France . . . is this: "I believe in Nature, and I believe only in Nature (there are good reasons for that). I believe that Art is, and cannot be other than, the exact reproduction of Nature . . . Thus an industry that could give us a result identical to Nature would be the absolute of art." A vengeful God has granted the wishes of this multitude. Daguerre was his Messiah. And now the public says to itself: "Since photography gives us every guarantee of exactitude that we could desire (they really believe that, the idiots!), then photography and Art are the same thing." From that moment our squalid society rushed, Narcissus to a man, to gaze at its trivial image on a scrap of metal . . . Some democratic writer ought to have seen here a cheap method of disseminating a loathing for history and for painting among the people . . .

—Baudelaire

Life itself is not the reality. We are the ones who put life into stones and pebbles.

—Frederick Sommer

The young artist has recorded, stone by stone, the cathedrals of Strasbourg and Rheims in over a hundred different prints. Thanks to him we have climbed all the steeples . . . what we never could have discovered through our own eyes, he has seen for us . . . one might think the saintly artists of the Middle Ages had foreseen the daguerreotype in placing on high their statues and stone carvings where birds alone circling the spires could marvel at their detail and perfection . . . The entire cathedral is reconstructed, layer on layer, in wonderful effects of sunlight, shadows, and rain. M. Le Secq, too, has built his monument.

—H. de Lacretelle,
in *La Lumière*, March 20, 1852

The need to bring things spatially and humanly "nearer" is almost an obsession today, as is the tendency to negate the unique or ephemeral quality of a given event by reproducing it photographically. There is an ever-growing compulsion to reproduce the object photographically, in close-up . . .

—Walter Benjamin

It is no accident that the photographer becomes a photographer any more than the lion tamer becomes a lion tamer.

—Dorothea Lange

If I were just curious, it would be very hard to say to someone, "I want to come to your house and have you talk to me

and tell me the story of your life." I mean people are going to say, "You're crazy." Plus they're going to keep mighty guarded. But the camera is a kind of license. A lot of people, they want to be paid that much attention and that's a reasonable kind of attention to be paid.

—Diane Arbus

. . . Suddenly a small boy dropped to the ground next to me. I realized then that the police were not firing warning shots. They were shooting into the crowd. More children fell . . . I began taking pictures of the little boy who was dying next to me. Blood poured from his mouth and some children knelt next to him and tried to stop the flow of blood. Then some children shouted they were going to kill me . . . I begged them to leave me alone. I said I was a reporter and was there to record what happened. A young girl hit me on the head with a rock. I was dazed, but still on my feet. Then they saw reason and some led me away. All the time helicopters circled overhead and there was the sound of shooting. It was like a dream. A dream I will never forget.

—from the account by Alf Khumalo, a black
reporter on the *Johannesburg Sunday Times*,
of the outbreak of riots in Soweto, South Africa,
published in *The Observer* [London],
Sunday, June 20, 1976

Photography is the only "language" understood in all parts of the world, and bridging all nations and cultures, it links the family of man. Independent of political influence—where people are free—it reflects truthfully life and events, allows us to share in the hopes and despair of others, and illuminates political and social conditions. We become the eye-witnesses of the humanity and inhumanity of mankind . . .

—Helmut Gernsheim
(*Creative Photography* [1962])

Photography is a system of visual editing. At bottom, it is a matter of surrounding with a frame a portion of one's cone of vision, while standing in the right place at the right time. Like chess, or writing, it is a matter of choosing from among given possibilities, but in the case of photography the number of possibilities is not finite but infinite.

—John Szarkowski

Sometimes I would set up the camera in a corner of the room, sit some distance away from it with a remote control in my hand, and watch our people while Mr. Caldwell talked with them. It might be an hour before their faces or gestures gave us what we were trying to express, but the instant it occurred the scene was imprisoned on a sheet of film before they knew what had happened.

—Margaret Bourke-White

The picture of Mayor William Gaynor of New York at the moment of being shot by an assassin in 1910. The Mayor was about to board a ship to go on holiday in Europe as an American newspaper photographer arrived. He asked the Mayor to pose for a picture and as he raised his camera two shots were fired from the crowd. In the midst of this confusion the photographer remained calm and his picture of the blood-spattered Mayor lurching into the arms of an aide has become part of photographic history.

—a caption in *"Click"*:
A Pictorial History of the Photograph (1974)

I have been photographing our toilet, that glossy enameled receptacle of extraordinary beauty . . . Here was every sensuous curve of the "human figure divine" but minus the imperfections. Never did the Greeks reach a more significant consummation to their culture, and it somehow reminded me, forward movement of finely progressing contours, of the Victory of Samothrace.

—Edward Weston

Good taste at this time in a technological democracy ends up to be nothing more than taste prejudice. If all that art does is create good or bad taste, then it has failed completely. In the question of taste analysis, it is just as easy to express good or bad taste in the kind of refrigerator, carpet or armchair that you have in your home. What good camera artists are trying

to do now is to raise art beyond the level of mere taste. Camera Art must be completely devoid of logic. The logic vacuum must be there so that the viewer applies his own logic to it and the work, in fact, makes itself before the viewer's eyes. So that it becomes a direct reflection of the viewer's consciousness, logic, morals, ethics and taste. The work should act as a feedback mechanism to the viewer's own working model of himself.

—Les Levine ("Camera Art," in *Studio International*, July/August 1975)

Women and men—it's an impossible subject, because there can be no answers. We can find only bits and pieces of clues. And this small portfolio is just the crudest sketches of what it's all about. Maybe, today, we're planting the seeds of more honest relationships between women and men.

—Duane Michals

"Why do people keep photographs?"

"Why? Goodness knows! Why do people keep things—junk—trash, bits and pieces. They do—that's all there is to it!"

"Up to a point I agree with you. Some people keep things. Some people throw everything away as soon as they have done with it. That, yes, it is a matter of temperament. But I speak now especially of photographs. Why do people keep, in particular, *photographs?*"

"As I say, because they just don't throw things away. Or else because it reminds them—"

Poirot pounced on the words.

"Exactly. *It reminds them*. Now again we ask—why? *Why* does a woman keep a photograph of herself when young? And I say that the first reason is, essentially, vanity. She has been a pretty girl and she keeps a photograph of herself to remind her of what a pretty girl she was. It encourages her when her mirror tells her unpalatable things. She says, perhaps, to a friend, 'That was me when I was eighteen . . .' and she sighs . . . You agree?"

"Yes—yes, I should say that's true enough."

"Then that is reason No. 1. Vanity. Now reason No. 2. Sentiment."

"That's the same thing?"

"No, no, not quite. Because this leads you to preserve, not only your own photograph but that of someone else . . . A picture of your married daughter—when she was a child sitting on a hearthrug with tulle round her . . . Very embarrassing to the subject sometimes, but mothers like to do it. And sons and daughters often keep pictures of their mothers, especially, say, if their mother died young. 'This was my mother as a girl.'"

"I'm beginning to see what you're driving at, Poirot."

"And there is, possibly, a *third* category. Not vanity, not sentiment, not love—perhaps *hate*—what do you say?"

"Hate?"

"Yes. To keep a desire for revenge alive. Someone who has injured you—you might keep a photograph to remind you, might you not?"

—from Agatha Christie's
Mrs. McGinty's Dead (1951)

Previously, at dawn that day, a commission assigned to the task had discovered the corpse of Antonio Conselheiro. It was lying in one of the huts next to the arbor. After a shallow layer of earth had been removed, the body appeared wrapped in a sorry shroud—a filthy sheet—over which pious hands had strewn a few withered flowers. There, resting upon a reed mat, were the last remains of the "notorious and barbarous agitator" ... They carefully disinterred the body, precious relic that it was—the sole prize, the only spoils of war this conflict had to offer!—taking the greatest of precautions to see that it did not fall apart ... They photographed it afterward and drew up an affidavit in due form, certifying its identity; for the entire nation must be thoroughly convinced that at last this terrible foe had been done away with.

—from Euclides da Cunha's
Rebellion in the Backlands (1902)

Men still kill one another, they have not yet understood how they live, why they live; politicians fail to observe that the earth is an entity, yet television (Telehor) has been invented: the "Far Seer"—tomorrow we shall be able to

look into the heart of our fellow-man, be everywhere and yet be alone; illustrated books, newspapers, magazines are printed—in millions. The unambiguousness of the real, the truth in the everyday situation is there for all classes. **The *hygiene of the optical*, the health of the visible is slowly filtering through.**

—László Moholy-Nagy (1925)

As I progressed further with my project, it became obvious that it was really unimportant where I chose to photograph. The particular place simply provided an excuse to produce work . . . you can only see what you are ready to see—what mirrors your mind at that particular time.

—George Tice

I photograph to find out what something will look like photographed.

—Garry Winogrand

The Guggenheim trips were like elaborate treasure hunts, with false clues mixed among the genuine ones. We were always being directed by friends to their own favorite sights or views or formations. Sometimes these tips paid off with real Weston prizes; sometimes the recommended item proved to be a dud . . . and we drove for miles with no pay-offs. By that time, I had reached the point of taking no

pleasure in scenery that didn't call Edward's camera out, so he didn't risk much when he settled back against the seat saying, "I'm not asleep—just resting my eyes"; he knew my eyes were at his service, and that the moment anything with a "Weston" look appeared, I would stop the car and wake him up.

—Charis Weston (quoted in Ben Maddow,
Edward Weston: Fifty Years [1973])

Polaroid's SX-70. It won't let you stop.
Suddenly you see a picture everywhere you look . . .
Now you press the red electric button. Whirr . . . whoosh . . . and there it is. You watch your picture come to life, growing more vivid, more detailed, until minutes later you have a print as real as life. Soon you're taking rapid-fire shots—as fast as every 1.5 seconds!—as you search for new angles or make copies on the spot. The SX-70 becomes like a part of you, as it slips through life effortlessly . . .

—advertisement (1975)

. . . we *regard* the photograph, the picture on our wall, as the object itself (the man, landscape, and so on) depicted there.

This need not have been so. We could easily imagine people who did not have this relation to such pictures. Who, for example, would be repelled by photographs, because a

face without colour and even perhaps a face in reduced pro-
portions struck them as inhuman.

—Wittgenstein

Is it an instant picture of . . .

> the destructive test of an axle?
> the proliferation of a virus?
> a forgettable lab setup?
> the scene of the crime?
> the eye of a green turtle?
> the divisional sales chart?
> chromosomal aberrations?
> page 173 of Gray's Anatomy?
> an electrocardiogram read-out?
> a line conversion of half-tone art?
> the three-millionth 8¢ Eisenhower stamp?
> a hairline fracture of the fourth vertebra?
> a copy of that irreplaceable 35mm slide?
> your new diode, magnified 13 times?
> a metallograph of vanadium steel?
> reduced type for mechanicals?
> an enlarged lymph node?
> the electrophoresis results?
> the world's worst malocclusion?
> the world's best-corrected malocclusion?

As you can see from the list . . . there's no limit to the kind of
material that people need to record. Fortunately, as you can

see from the list of Polaroid Land cameras below, there's almost no limit to the kind of photographic records you can get. And, since you get them on the spot, if anything's missing, you can re-shoot on the spot . . .

<div align="right">—advertisement (1976)</div>

An object that tells of the loss, destruction, disappearance of objects. Does not speak of itself. Tells of others. Will it include them?

<div align="right">—Jasper Johns</div>

Belfast, Northern Ireland—The people of Belfast are buying picture postcards of their city's torment by the hundreds. The most popular shows a boy throwing a stone at a British armored car . . . other cards show burned-out homes, troops in battle positions on city streets and children at play amid smoking rubble. Each card sells for approximately 25 cents in the three Gardener's shops.

"Even at that price, people have been buying them in bundles of five or six at a time," said Rose Lehane, manager of one shop. Mrs. Lehane said that nearly 1,000 cards were sold in four days.

Since Belfast has few tourists, she said, most of the buyers are local people, mostly young men who want them as "souvenirs."

Neil Shawcross, a Belfast man, bought two complete sets of the cards, explaining, "I think they're interesting mementoes of

the times and I want my two children to have them when they grow up."

"The cards are good for people," said Alan Gardener, a director of the chain. "Too many people in Belfast try to cope with the situation here by closing their eyes and pretending it doesn't exist. Maybe something like this will jar them into seeing again."

"We have lost a lot of money through the troubles, with our stores being bombed and burned down," Mr. Gardener added. "If we can get a bit of money back from the troubles, well and good."

—from *The New York Times*, October 29, 1974
("Postcards of Belfast Strife Are Best-Sellers There")

Photography is a tool for dealing with things everybody knows about but isn't attending to. My photographs are intended to represent something you don't see.

—Emmet Gowin

The camera is a fluid way of encountering that other reality.

—Jerry N. Uelsmann

Oswiecim, Poland—Nearly 30 years after Auschwitz concentration camp was closed down, the underlying horror of the place seems diminished by the souvenir stands, Pepsi-Cola signs and the tourist-attraction atmosphere.

Despite chilling autumn rain, thousands of Poles and some

foreigners visit Auschwitz every day. Most are modishly dressed and obviously too young to remember World War II.

They troop through the former prison barracks, gas chambers and crematoria, looking with interest at such gruesome displays as an enormous showcase filled with some of the human hair the S.S. used to make into cloth . . . At the souvenir stands, visitors can buy a selection of Auschwitz lapel pins in Polish and German, or picture postcards showing gas chambers and crematoria, or even souvenir Auschwitz ballpoint pens which, when held up to the light, reveal similar pictures.

—from *The New York Times*,
November 3, 1974 ("At Auschwitz,
a Discordant Atmosphere of Tourism")

The media have substituted themselves for the older world. Even if we should wish to recover that older world we can do it only by an intensive study of the ways in which the media have swallowed it.

—Marshall McLuhan

. . . Many of the visitors were from the countryside, and some, unfamiliar with city ways, spread out newspapers on the asphalt on the other side of the palace moat, unwrapped their home-cooking and chopsticks and sat there eating and chatting while the crowds sidestepped. The Japanese addiction to snapshots rose to fever pitch under the impetus of the august backdrop of the palace gardens. Judging by the steady clicking of the

shutters, not only everybody present but also every leaf and blade of grass must now be recorded on film, in all their aspects.

—from *The New York Times,* May 3, 1977
("Japan Enjoys 3 Holidays of 'Golden Week'
by Taking a 7-Day Vacation from Work")

I'm always mentally photographing everything as practice.

—Minor White

The daguerreotypes of all things are preserved ... the imprints of all that has existed live, spread out through the diverse zones of infinite space.

—Ernest Renan

These people live again in print as intensely as when their images were captured on the old dry plates of sixty years ago ... I am walking in their alleys, standing in their rooms and sheds and workshops, looking in and out of their windows. And they in turn seem to be aware of me.

—Ansel Adams (from the Preface to
Jacob A. Riis: Photographer & Citizen [1974])

Thus in the photographic camera we have the most reliable aid to a beginning of objective vision. Everyone will be compelled to see that which is optically true, is explicable in its own terms, is objective, before he can arrive at any possible subjective position. This will abolish that pictorial and

imaginative association pattern which has remained un-superseded for centuries and which has been stamped upon our vision by great individual painters.

We have—through a hundred years of photography and two decades of film—been enormously enriched in this respect. **We may say that we see the world with entirely different eyes.** Nevertheless, the total result to date amounts to little more than a visual encyclopaedic achievement. This is not enough. We wish to **produce** systematically, since it is important for life that we create *new relationships*.

—László Moholy-Nagy (1925)

Any one who knows what the worth of family affection is among the lower classes, and who has seen the array of little portraits stuck over a labourer's fireplace . . . will perhaps feel with me that in counteracting the tendencies, social and industrial, which every day are sapping the healthier family affections, the sixpenny photograph is doing more for the poor than all the philanthropists in the world.

—*Macmillan's Magazine* [London], September 1871

Who, in his opinion, would buy an instant movie camera? Dr. Land said he expects the housewife to be a good prospect. "All she has to do is point the camera, press the shutter release and in minutes relive her child's cute moment, or perhaps, birthday party. Then, there is the large number of people who prefer pictures to equipment. Golf and tennis fans can

evaluate their swings in instant replay; industry, schools and other areas where instant replay coupled with easy-to-use equipment would be helpful . . . Polavision's boundaries are as wide as your imagination. There is no end to the uses that will be found for this and future Polavision cameras."

—from *The New York Times*, May 8, 1977
("A Preview of Polaroid's New Instant Movies")

Most modern reproducers of life, even including the camera, really repudiate it. We gulp down evil, choke at good.

—Wallace Stevens

The war had thrust me, as a soldier, into the heart of a mechanical atmosphere. Here I discovered the beauty of the fragment. I sensed a new reality in the detail of a machine, in the common object. I tried to find the plastic value of these fragments of our modern life. I rediscovered them on the screen in the close-ups of objects which impressed and influenced me.

—Fernand Léger (1923)

575.20 fields of photography

aerophotography, aerial photography
astrophotography
candid photography
chromophotography
chronophotography
cinematography

cinephotomicrography
cystophotography
heliophotography
infrared photography
macrophotography
microphotography
miniature photography
phonophotography
photogrammetry
photomicography
photospectroheliography
phototopography
phototypography
phototypy
pyrophotography
radiography
radiophotography
sculptography
skiagraphy
spectroheliography
spectrophotography
stroboscopic photography
telephotography
uranophotography
X-ray photography
—from *Roget's International Thesaurus,*
Third Edition

In the spring of 1921, two automatic photographic machines, recently invented abroad, were installed in Prague, which reproduced six or ten or more exposures of the same person on a single print.

When I took such a series of photographs to Kafka I said light-heartedly: "For a couple of krone one can have oneself photographed from every angle. The apparatus is a mechanical *Know-Thyself.*"

"You mean to say, the *Mistake-Thyself,*" said Kafka, with a faint smile.

I protested: "What do you mean? The camera cannot lie!"

"Who told you that?" Kafka leaned his head toward his shoulder. "Photography concentrates one's eye on the superficial. For that reason it obscures the hidden life which glimmers through the outlines of things like a play of light and shade. One can't catch that even with the sharpest lens. One has to grope for it by feeling . . . This automatic camera doesn't multiply men's eyes but only gives a fantastically simplified fly eye's view."

—from Gustav Janouch's
Conversations with Kafka

Life appears always fully present along the epidermis of his body: vitality ready to be squeezed forth entire in fixing the instant, in recording a brief weary smile, a twitch of the

hand, the fugitive pour of sun through clouds. And not a tool, save the camera, is capable of registering such complex ephemeral responses, and expressing the full majesty of the moment. No hand can express it, for the reason that the mind cannot retain the unmutated truth of a moment sufficiently long to permit the slow fingers to notate large masses of related detail. The impressionists tried in vain to achieve the notation. For, consciously or unconsciously, what they were striving to demonstrate with their effects of light was the truth of moments; impressionism has ever sought to fix the wonder of the here, the now. But the momentary effects of lighting escaped them while they were busy analyzing; and their "impression" remains usually a series of impressions superimposed one upon the other. Stieglitz was better guided. He went directly to the instrument made for him.

—Paul Rosenfeld

The camera is my tool. Through it I give a reason to everything around me.

—André Kertész

A double leveling down, or a method of leveling down which double-crosses itself
With the daguerreotype everyone will be able to have their portrait taken—formerly it was only the prominent; and at

the same time everything is being done to make us all look exactly the same—so that we shall only need one portrait.

—Kierkegaard (1854)

Make picture of kaleidoscope.

—William H. Fox Talbot
(ms. note dated February 18, 1839)

SUSAN SONTAG

REGARDING THE PAIN OF OTHERS

'A coruscating sermon on how we picture suffering' *The New York Times*

What is the purpose of images of pain and suffering? Can there be any real justification for the creation, and consumption, of such images?

In this seminal volume, Susan Sontag examines the uses and meanings of images, from inspiring dissent to fostering violence to creating apathy. And through this lens she considers the nature of war, the limits of sympathy, and the obligations of conscience.

'A far-reaching set of ruminations [. . .] on what it means to be alive and alert in the twenty-first century' *Independent*

'Sontag is on top form: devastating' *Los Angeles Times*

'Simple, elegant, fiercely persuasive' *Metro*

He just wanted a decent book to read ...

Not too much to ask, is it? It was in 1935 when Allen Lane, Managing Director of Bodley Head Publishers, stood on a platform at Exeter railway station looking for something good to read on his journey back to London. His choice was limited to popular magazines and poor-quality paperbacks – the same choice faced every day by the vast majority of readers, few of whom could afford hardbacks. Lane's disappointment and subsequent anger at the range of books generally available led him to found a company – and change the world.

'We believed in the existence in this country of a vast reading public for intelligent books at a low price, and staked everything on it'
Sir Allen Lane, 1902–1970, founder of Penguin Books

The quality paperback had arrived – and not just in bookshops. Lane was adamant that his Penguins should appear in chain stores and tobacconists, and should cost no more than a packet of cigarettes.

Reading habits (and cigarette prices) have changed since 1935, but Penguin still believes in publishing the best books for everybody to enjoy. We still believe that good design costs no more than bad design, and we still believe that quality books published passionately and responsibly make the world a better place.

So wherever you see the little bird – whether it's on a piece of prize-winning literary fiction or a celebrity autobiography, political tour de force or historical masterpiece, a serial-killer thriller, reference book, world classic or a piece of pure escapism – you can bet that it represents the very best that the genre has to offer.

Whatever you like to read – trust Penguin.